Teach Yourself
Henna Tattoo

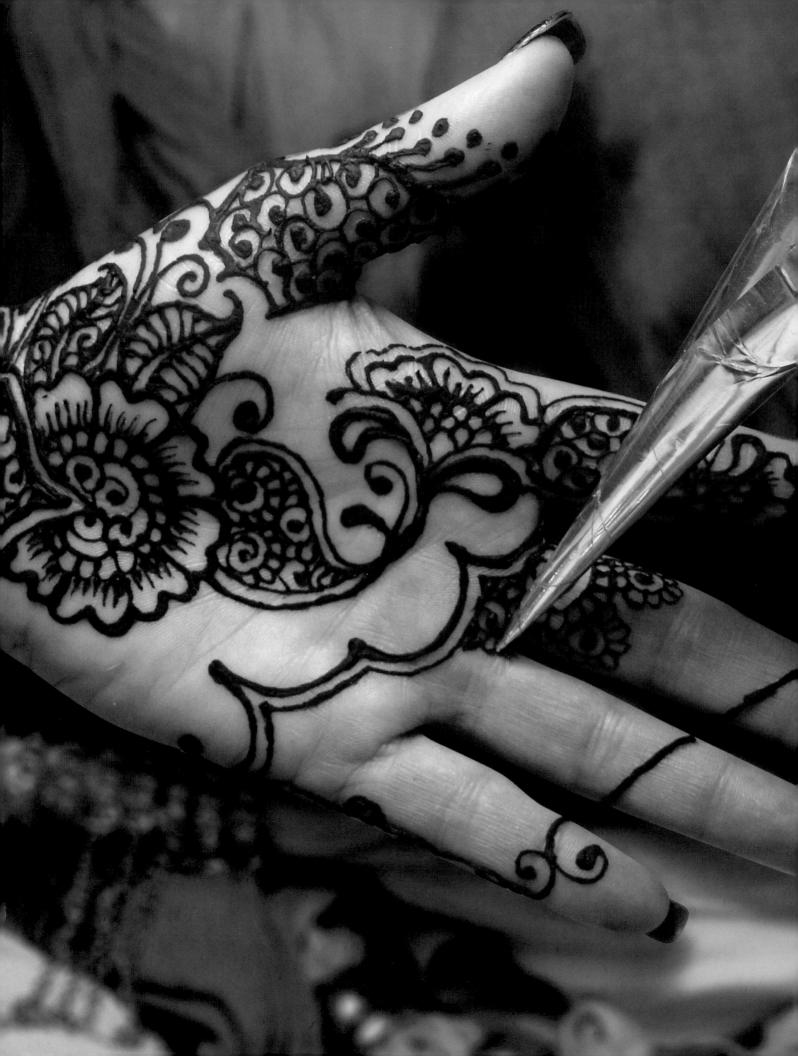

Teach Yourself Henna Tattoo

Making Mehndi Art with Easy-to-Follow Instructions, Patterns, and Projects

BRENDA ABDOYAN

DESIGN ORIGINALS

an Imprint of Fox Chapel Publishing

www.d-originals.com

ACKNOWLEDGMENTS

To my husband, Anto, whom I love dearly
My daughter, Nic, and all the little chiclettes
My Mom, who is my hero, and my Dad, who has been hers
To all henna artisans who have been and still are the source of my inspiration, namely,
Catherine Cartwright-Jones of TapDancing Lizard LLC and TheHennaPage.com
And to all the friends, you know who you are, who painfully listened to me rave about
henna for years!

ISBN 978-1-4972-0070-8

© 2012, 2016 by Brenda Abdoyan and New Design Originals Corporation, www.d-originals.com, an imprint of Fox Chapel Publishing, 800-457-9112, 1970 Broad Street, East Petersburg, PA 17520.

Photography by Brenda Abdoyan, Bajidoo, Inc.

Printed in Singapore
First printing

ABOUT THE AUTHOR

Brenda Abdoyan is a mixed-media artist who takes her inspiration from everyday life. The base of Brenda's work is seated in realism, and she then incorporates her flare for the art of henna. She is the artist and designer behind Bajidoo, a jewelry and altered couture fashion design studio. Recently, she won top honors for the Designer Golden Press Kit Award from the Craft and Hobby Association. Brenda holds a degree in business administration and project management from the University of Phoenix. After more than 20 years as a senior business analyst in corporate America, Brenda finally decided to take her art off the studio shelf and share her talent with others by teaching and sharing her passion. The art of henna was the road that took her home. Her first YouTube video on henna tattoo design led to her work being included in the March 2009 cable channel series My Art by Ovation Television. From there, she has expanded her canvas to include leather, wood, fabric, and bangles. When Brenda's designs landed on bangle jewelry, she was invited to appear on the cable network Jewelry Television as a guest expert, demonstrating her design skills on live TV. Brenda's unique designs also caught the eye of Royal Caribbean International, which placed her handiwork aboard the ship *Allure of the Seas*. Most recently, she was featured as editor's choice in the book *Incite, Dreams Realized: The Best of Mixed Media*. Her YouTube presence has recently passed the 2.7 million view mark and is still climbing.

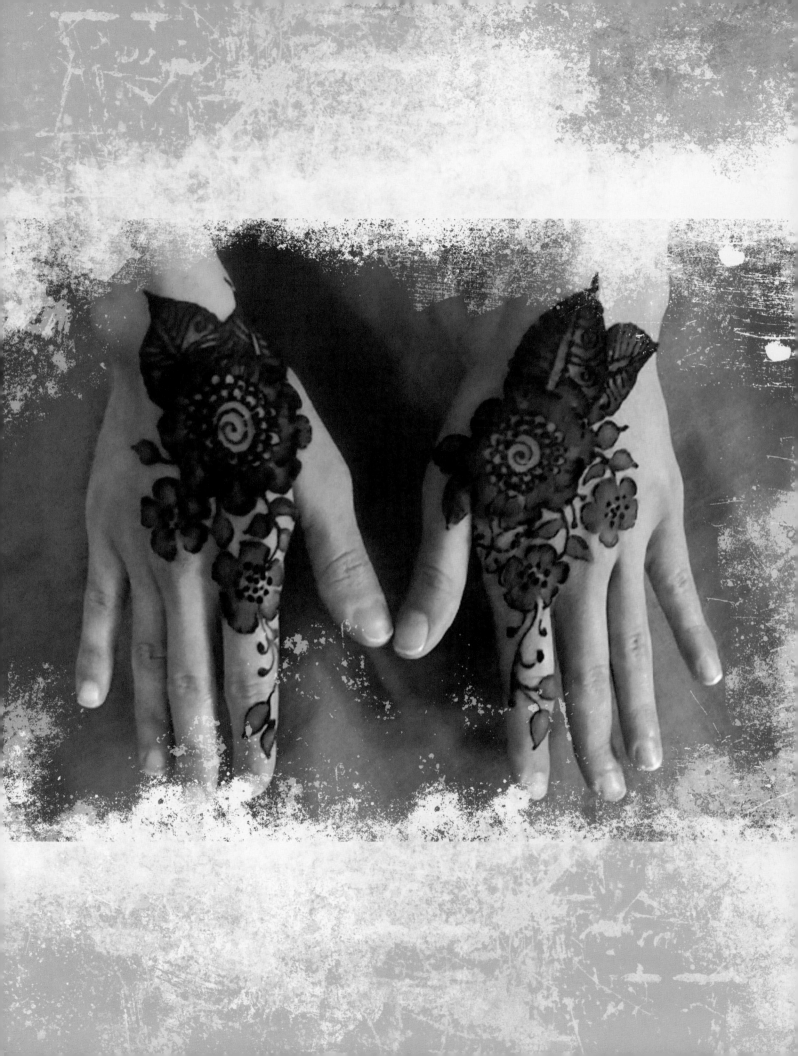

CONTENTS

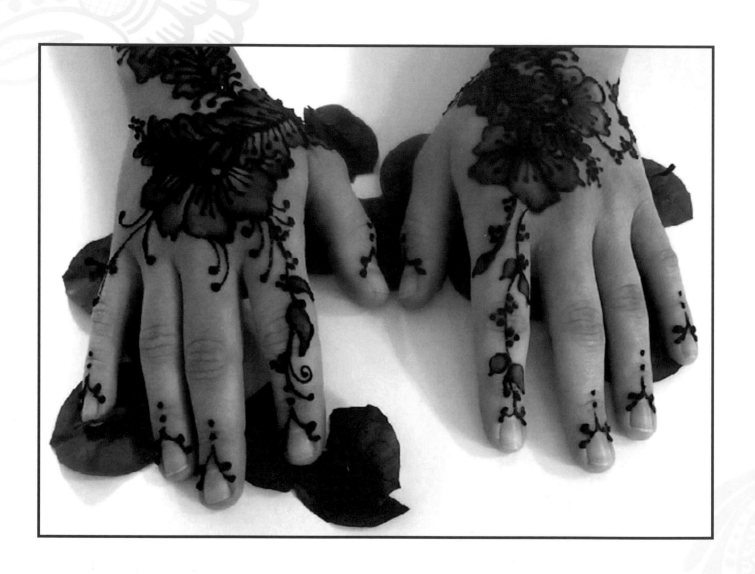

Teach Yourself Henna Tattoo

INTRODUCTION

*A prudent question is one-half of wisdom. —
Francis Bacon*

My henna saga began with a trip to the Middle East in 2000. Unlike the henna tattoo artist you may find on the beach in summer or in your favorite theme parks, henna artists in the Middle East apply tattoos behind the blacked-out windows of a beauty salon. The windows are blacked out to preserve the modesty of the ladies inside; the henna application is a complete experience.

A friend (the sister of the man who would later become my husband) and I entered the salon and were led up a dark, steep, narrow stairway. When we reentered the light at the top of stairs, we were in another world. Aromas assaulted us—cardamom spice in Arabic coffee (the essential oils used in henna paste) and burning incense.

The room, which comprised the entire upper floor, had no stations where a guest would sit in a specific chair for her henna application. Instead, the space was nearly empty in the center with banks of ornately decorated pillows along the sides. We simply sat on a mass of these overly soft pillows and the work began.

Since both my hands and feet were being done, four young girls worked through the designs, one on each hand and each foot. These four girls talked and giggled amongst themselves, only occasionally putting together a few words in English to ask me questions about my prior experience with henna tattoos (at that time, I had none). Something about those moments ignited a spark in me that continues to burn.

While the use of henna for tattoos is difficult to trace, evidence shows that it stretches back more than 5,000 years to the days of ancient Egypt when a henna dye was used to stain the fingers and toes of the pharaohs prior to their mummification. Henna tattooing has a long history among many Eastern cultures. The designs tend to fall into four styles based on the region. The Middle Eastern style in the Arab world features floral designs that do not follow a distinctive pattern. In North Africa, henna tattoos are geometrical and follow the shape of the wearer's hands and feet. In India and Pakistan, the designs cover more of the body, extending up arms and legs to give the impression of gloves or stockings. Henna tattoos in Indonesia and southern Asia are often blocks of color on the tips of the fingers and toes.

Many of the historical styles of henna tattoos remain popular today, but their use has grown to include Celtic designs, Chinese characters,

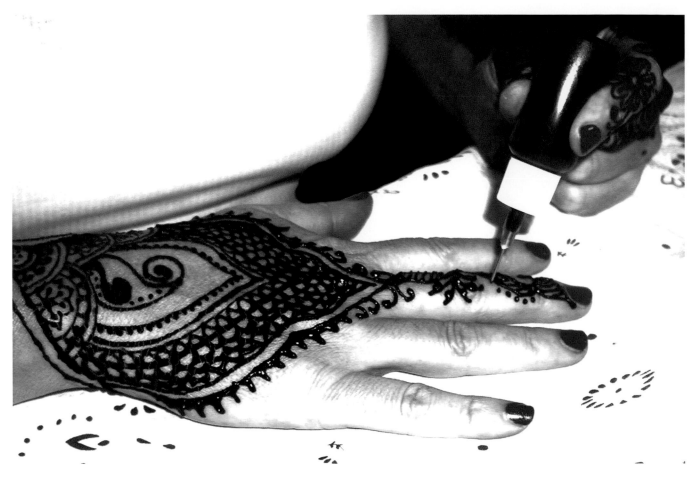

and American Indian symbols. Because of the temporary nature of henna tattoos, many people have begun experimenting with designs that express their individual styles and beliefs.

Culturally, the most common modern reference to henna tattooing is its use in traditional Hindu wedding ceremonies. Intricate designs, known as Mehndi, are applied to the bride's hands and feet to symbolize her commitment to her husband-to-be. Since the henna paste must remain on the skin for a couple of days, it restricts the movements and tasks of the bride. Its application gives her time to reflect on her upcoming marriage.

Henna is like many things: What you get out of it is directly proportional to what you put into it. While I started learning about henna in 2000, I only began to work with henna paste at the beginning of 2008. Yes, you read that right.

The first henna tattoo I made was on my right foot. I sat on my patio and drew on my foot.

I did a terrible job. I made the paste wrong; it was too thin. I had no coordination to create the images I had seen in books and online. I was completely frustrated. Even worse, after all my trouble, my ugly little tattoo image never even got dark! In no time at all I figured out that knowing the history and traditions of henna was fulfilling on one level, but tattoos wouldn't just spring forth from my hands because I had studied so diligently. To find fulfillment, I had to do more work in an entirely new direction.

This book is my way of helping you skip some or all of my frustration. I've included an extensive section on making henna paste and applying it (page 12). You will find information on the basic lines you'll need to master before creating beautiful tattoos. Don't skip this

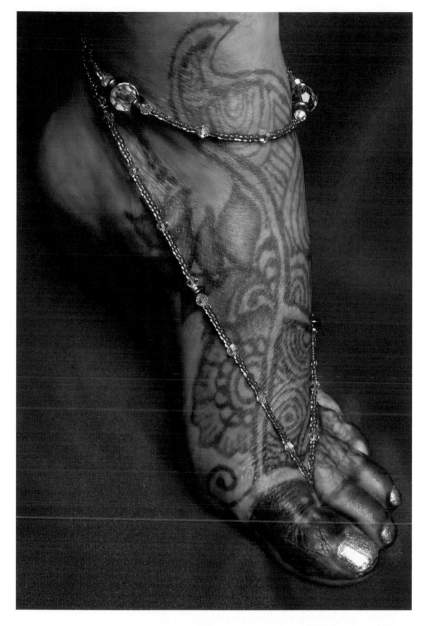

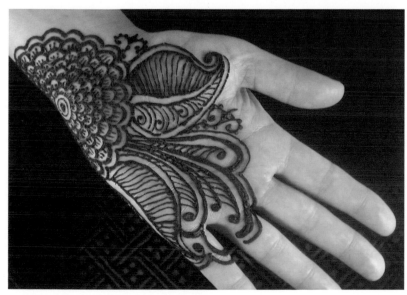

section! The better control you have in making the basic lines—which are the foundation of all henna tattoos—the better your finished tattoos will look.

The next section (page 26) focuses on applying henna tattoos to the body. Work through the projects to develop your henna tattooing skills. There are tons of gallery photos here to inspire you.

The next section is filled with designs for use on hands, feet, lower back, and shoulders (page 46). As you become more familiar with henna tattoos, you will be able to adapt these designs. I've also included the templates I use to develop new designs. Just follow the shape of the hand or foot to create your own unique henna tattoos.

Finally, the stain left behind from the application of henna paste is not just ideal for skin, but it also works well on other mediums, including wood and leather. Henna designs applied to the latter may fade a bit, but they won't wear off like the henna tattoos applied to your skin! Check out some of my ideas for henna on objects on page 98.

If you try henna tattooing and have difficulty, snap a picture and email it to me at info@bajidoo.com. I will respond as quickly as I am able with some suggestions.

A random event on a short holiday was the spark that quickly caused a firestorm of creativity deep in my heart. From the first instant that henna entered my life, it was kismet. I hope this book provides a similar spark of passion in you. So let's get started making the paste and creating beautiful henna tattoos.

Regards,
Brenda Abdoyan, Bajidoo, Inc.

SETTING UP

The first step in mastering the art of henna tattoos is to make sure you have the right materials on hand. The items you'll need to create your own henna tattoos are not costly, but you'll want to have everything readily available before you get started. After that, it's practice, practice, practice!

Making Henna Paste

Before you do anything else you must first make or buy henna paste.

Henna paste is made by mixing a liquid with the powder from the dried, crushed leaves of a bush, *Lawsonia inermis*, which grows in the dry, hot regions of the Middle East. When applied to the skin, the greenish paste leaves behind an orange-red stain. This stain is only temporary and will wear away as the skin exfoliates over the next three to four weeks.

Henna paste is easy to make on your own, or you can purchase it from arts and craft supply stores (see Resources at the back of this book). If you buy premade henna paste, be sure to check the expiration date. It should be clearly marked on the package.

I prefer to make my own henna paste. The process of making the paste by hand is just one small part of the whole henna experience.

HOMEMADE HENNA PASTE

If you choose to make your own henna paste, you will need a recipe. I started experimenting with my henna recipe in 2005 and perfected it through trial and error in 2008. I suggest you start your trials with my recipe and then alter it if you need to. You'll find notes in the ingredient list below that will help you determine what to change.

My current recipe for henna paste has turned out perfectly every time for me, but when I first began to make henna paste, I goofed it up a lot, so give yourself space for making mistakes.

TIP A good test for the correct consistency is to take ¼ tsp. of the paste and drop it on a plate. It should stand up from the surface of the plate and retain much of its form, similar to the way frosting on a cake retains its shape from the strokes of the spatula blade.

Above all be patient with yourself. All good things take some amount of time to perfect.

Let's gather up the ingredients you'll need and get started on the paste! In the back of this book I have included some Web sites and other suggestions for where to get the ingredients in the list.

Henna powder is made from the leaves of a bush that grows in the dry Middle Eastern regions.

To make henna paste you'll need to mix the powder with acidic liquids like lemon juice and with essential oils both from seeds and distilled sources.

RECIPE: HENNA PASTE

- 6 oz. (177 ml) brewed coffee, black
- 1 Tbsp. (15 g) each of peppercorns, whole cloves, and whole cumin seeds, mixed together
- 2 cinnamon sticks
- 1.75 oz. (50 g) henna powder
- Juice of 1 lemon, or about 2 tbsp. (90 ml) reconstituted juice
- 2 tsp. (10 g) granulated sugar
- 2 tsp. (30 ml) tea tree oil

TIP Not quite ready to tattoo yet but have already mixed your paste? Simply keep it in the zipper-top plastic bag and pop it in the freezer. It will keep there for two to three months. Thaw it at room temperature when you're ready to tattoo.

1. Brew 6 oz. of strong black coffee.

2. Drop a good-sized handful of peppercorns, whole cloves, and whole cumin seeds plus a couple cinnamon sticks into a hot cup of black coffee. Let it steep for 3 to 4 minutes.

3. In a 2- to 3-cup (.5 to .75 l) plastic container with a lid, put about 1.75 oz. (50 g) of henna powder (half a box of Jamila if you chose this brand).

4. Pour the coffee mixture, a little at a time, through a strainer into the henna powder, mixing the liquid in at each interval until the mixture resembles mashed potatoes.

5. Squeeze the juice of 1 lemon through the strainer into the henna paste.

6. Add sugar, and mix well. Let the mixture stand covered at 70°F to 90°F for about 10 to 20 hours. After it has rested, the paste should look very dark green and the surface of the paste will have a light sheen.

7. Add tea tree oil, and stir. The paste should be similar in thickness to cake frosting, whipped butter, or toothpaste. Adjust the consistency if necessary by adding more lemon juice.

8. Spoon the paste into a zipper-top bag to let it rest 72 hours at 70°F to 90°F. Store the paste in the plastic bag until it is time to tattoo. If the tattooing will not occur within the next several days, freeze the paste in the bag and thaw it when you're ready to begin tattooing. Premixed paste will keep for 2 to 3 months in the freezer.

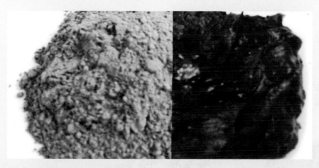

The henna powder (left) turns into a paste (right) that will stain the skin temporarily.

HENNA PASTE NECESSITIES

Henna powder. Be sure to get fresh powder; the year of the crop should be listed on the box or bag. Make sure that the packaging does not mention "hair dye." Henna on its own can add shine to natural hair, but henna that is used for hair coloring often includes dyes that are harmful to the skin and can result in allergic reactions and even burns. I often mix two brands of henna powder together in one recipe.

Coffee. You can use any type of coffee derived from the coffee bean—from instant to French press—as long as you brew it strong and hot, but not boiling. Contrary to popular belief, the coffee doesn't add color to the paste; however, the acid in the coffee helps to pull the color out of the crushed henna leaves. Don't have coffee on hand? A strong, dark, black tea will provide the same effect.

Lemon juice. Just like coffee, lemon juice adds acid, and acid breaks down the cellular structure of the henna powder to bring out the color. Either squeeze the juice from one lemon or use an equal amount of reconstituted lemon juice. I've also heard of other acidic ingredients being substituted for lemon juice. Apple cider vinegar is one option, but the smell would be quite strong and likely unpleasant compared to lemon!

> **TIP** To test if your henna is ready to use for tattooing, place the zipper-top plastic bag on a white paper towel or plain sheet of white tablet paper and wait approximately 15 to 20 minutes. Lift the bag at the end of the time period. The paper should have a light orange shadow where the bag was sitting. Bingo, you're ready to go!

Peppercorns, whole cloves, cinnamon sticks, whole cumin seeds. Yes, they smell good, but it's not the smell we're after in a henna paste recipe. Seeds of any kind contain essential oils that act as an accelerator and give the henna powder an extra punch, making it just a little darker than it would be on its own. If you're making your own recipe, feel free to try the seeds from any plant, but make sure that you or your tattooee isn't allergic.

Tea tree oil. Another essential oil, this one is added directly to the paste for consistency as well as acceleration. If you can't find tea tree oil, substitute eucalyptus oil. If the rather strong smell of either of those oils doesn't appeal to you, try adding some lemon or lavender oil to the tea tree oil. Remember to check on allergies to essential oils before application.

White sugar. Sugar adds the stickiness that the henna paste needs to stay on the skin long enough to leave a nice stain behind. You can use any kind of sugar, or you can try honey instead.

Strainer. Use the strainer to remove the seeds from the coffee and any pulp or seeds from the lemon juice. Any solid objects in the finished paste may clog your applicator and cause your lines to have skips or blobs.

Sandwich-sized plastic bag with a zipper top. After the henna paste is mixed it needs to rest. A small bag with a secure closure will keep air from getting to the paste and making it hard.

It only takes about 10 minutes to make henna paste, but it is not ready to use for tattoos until it has rested at a temperature of 72°F to 80°F for at least 72 hours. Be sure to figure in this extra time when setting a time to do your tattoos. You'll need to make the paste at least three days before you want to start tattooing!

TRIAL AND ERROR

While trial and error are great ways to discover the ultimate henna paste recipe, not everyone has the several years I took to perfect a recipe. Here are some things I've learned to put you one step—or maybe two or three—ahead of the trial and error curve.

- You *can't* change the color that's left behind by natural henna paste. I've known people to try beet juice—which by itself will stain your hands red in a heartbeat—instead of coffee, but they ended up with the same orange-red color.

- You can make the stain from natural henna paste slightly darker by changing the types of essential oils (they come from the seeds) you use in your recipe or by wiping the area to be tattooed with a bit of tea tree or eucalyptus oil before applying the paste.

- If you really don't like the orange-red color of henna tattoos, you can try another natural temporary tattoo substance made from the pulp of the jagua fruit. Employed by native South American tribes, this gel leaves behind a dark blue-black stain. The mixture can be applied through a Mylar henna cone and leaves a tattoo that will last for seven to nine days.

- Try mixing two or more brands of henna powder in your recipe. You may find that the unique qualities of each growing region produce a more or less potent powder, giving your resulting tattoo a darker or lighter shade. I've tried Jamila and Henna from Yemen with good results.

- It's always good to sift henna powder right out of the bag before you mix it into your recipe, but that step is extremely important if you're planning to apply a tattoo that has intricate details. One piece of leaf or stem can jam your applicator, causing you to alter your design.

- Avoid making paste that is too thin; it will run and the definition of your tattoo will be lost. As an insurance policy, set aside 1 to 2 rounded tablespoons of sifted henna powder. If you make the henna paste too thin, simply add the extra powder back in to thicken the paste.

- Always add your liquid—coffee, lemon juice, oil—in small amounts. Think of the stated amounts in the recipe as guidelines. Getting the correct consistency of the final paste is more important than adding in the precise amounts of each ingredient. You want "mashed potatoes" after the first stage and "frosting" after the second stage.

- Whole seeds generally have more essential oils, but ground spices will have some as well. Use what you have on hand. Ground cinnamon, ground cloves, and ground pepper, for example, can be substituted for their whole counterparts.

> **CAUTION:**
> - Make sure that the henna powder packaging does not mention "hair dye." Henna on its own can add shine to natural hair, but henna that is used for hair coloring often includes dyes and chemicals that are harmful to the skin and can result in allergic reactions or even burns.
>
> - Be aware of allergies to essential oils and always research the essential oils you use. Undiluted essential oils are not safe to use directly on human skin, and some can have adverse effects for pregnant women and small children.

APPLYING HENNA PASTE

Henna paste can be applied to skin as tattoos or to other natural, porous surfaces (untreated wood, tambourine and drum heads, or leather, for example) as decoration.

SKIN

If you decide to work on skin, prepare the surface by swabbing it with alcohol. The alcohol will kill any germs on the surface of the skin and keep other germs from being transferred during the tattooing process.

Some people may choose to prepare the area by rubbing it with tea tree oil, eucalyptus oil, or any other essential oil mixed with some carrier oil. While these oils are a part of the natural henna paste recipe, the extra application directly to the skin may help to make the final tattoo just a bit darker.

Note: This preparation method will not kill germs and other bacteria.

Another consideration before applying henna paste to skin is to make sure the area is free of open wounds or recently healed scratches. The skin is your body's largest organ; be careful to avoid harming it in any way. Always, always, always do a test patch first to see how your body will react to the paste. The inner elbow is a good spot.

If you're not quite ready to freehand henna paste directly to the skin, you can use a brown-toned watercolor pencil to sketch out the design on your skin first. The pencil marks are removable if you don't like what you draw, and they can't be seen under the henna if you decide to apply the paste directly on top of the marks.

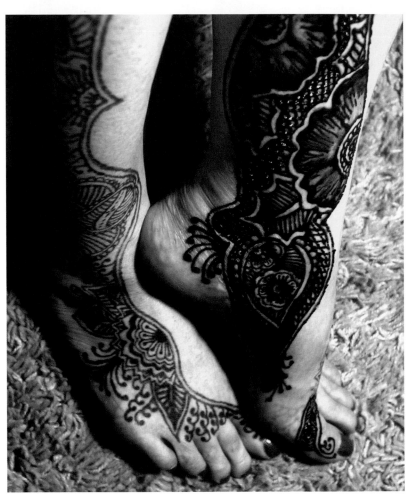

Henna paste can be removed after as little as two hours to reveal the orange-burgundy temporary tattoo left behind (left). Leaving the paste on longer, however, is always better.

TIP When it comes to henna tattoos, inquiry as to whether your subject is pregnant is not an invasion of privacy; it's a necessary safety measure. Some essential oils used in henna paste or as a preparation directly on the skin's surface can be harmful to pregnant women. Rosemary oil, for example, can send a woman into early labor. Always ask first!

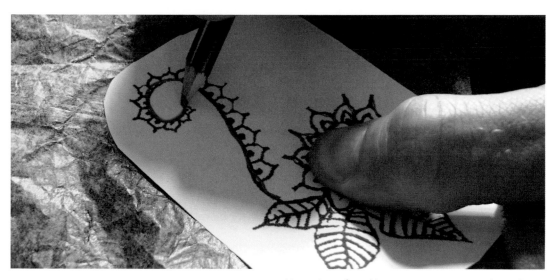

Use a piece of graphite paper to trace over an image in order to transfer it to an object.

OBJECTS

Because of the nature of henna paste, it will leave behind its signature orange-red stain on any natural, porous surface. Untreated wood is ideal. This wood must be completely natural—do not finish it with *any* substance, from chemical finishes, like varnish, to natural finishes, like linseed oil.

Leather is another surface that takes henna designs very well. You can decorate drum heads or tambourine skins, as well as lamp shades and other objects made out of untreated animal skins.

Again, if you're not quite ready to freehand a design directly on an object, try transferring it first by going over a copy of the tattoo with a graphite pencil. Press as lightly as possible to transfer the graphite to the surface; if your graphite goes on too dark you will see it later when the henna paste is removed.

CHOOSE AN APPLICATION TOOL

There are several ways to apply henna to a surface to create a tattoo design. Try each of the methods listed below until you find the one that is most comfortable for you.

Soft plastic squeeze bottle. Any type of small squeeze bottle that fits comfortably into your hand is ideal. Jacquard Products makes a variety of these types of bottles. Look for 1 ounce (30 ml) bottles. Anything larger will be hard to handle and anything smaller will be too stiff to squeeze.

Mylar cone. This method of applying henna paste is most popular, and it is the method I use throughout the book. Look for the how-to instructions on making your own Mylar cones in this chapter (page 20).

Syringe. Any type of syringe will work. Be sure to clip off the sharp tip and file the needle to a dull finish so it will not perforate the skin.

Paintbrush. Use a paintbrush to apply a wash of 1 part water and 1 part henna paste to an area you have mapped out prior to tattooing or within an outline of a tattoo for a two-toned effect. Choose a brush with bristles made from flexible natural fibers.

ROLL-YOUR-OWN HENNA CONE

Just like henna paste, applicators made from Mylar (a transparent gift wrap often used to wrap fresh-cut flowers) can be handmade or purchased. I'll give you instructions here to make your own, or you can purchase them premade through one of the suppliers listed in the back of the book (see Resources on page 110). Whichever method you choose, be sure to make or purchase two or three so you can quickly and efficiently apply lines of different widths.

To make a Mylar cone by hand, begin by cutting a 10" x 8" rectangular portion of Mylar (see right). Now cut the rectangle in two, from the longest point to opposite longest point. You will end up with two right triangles.

Place the triangle in front of you on a smooth, dry surface. Position the triangle so the long side is on the left if you're right handed, and on the right if you're left handed.

Locate the midway point along the longest side. Place your first digit (pointing finger) on that spot. From the shorter pointy side of the triangle, lift the bottom corner up and curl it over your finger to create a cone shape.

Using your thumb and first digit, guide the tip of the cone so that it keeps its shape—do not pinch or put pressure on the tip. Just keep it between your fingers so it remains tight in form. Continue rolling the cone from the other side until the triangle is completely rolled onto

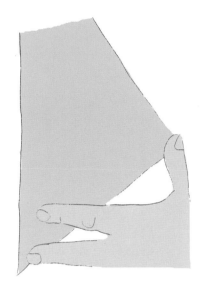
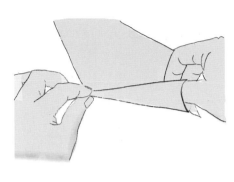

Cut a 10" x 8" (255 x 205mm) piece of Mylar into two triangles.

Lightly pinch the long side of the triangle at the midpoint. Start to roll the cone from the pointed side of the triangle.

The resulting cones should be tightly closed at the point.

TIP You need only about 50 grams (1.75 oz.) of henna powder to make enough paste for two hands, top and bottom, and the tops of both feet. And when mixed, that 50 grams (1.75 oz.) of dry powder will make just about the right amount to fill two standard "roll-your-own" applicator cones. You could make one super cone to hold all the paste, but I always make two: I clip one for a fine tip and the other for a bold or thicker line.

itself. When you're finished, it will resemble an ice cream cone; the tip will be completely closed. Tape the cone closed along the open side, leaving the top open.

Now you're ready to fill the cone about two-thirds full of henna paste. Clip the lower corner off one side of the zipper-top bag and squeeze the paste into your applicator. Do not overfill the cone. Overfull cones make a big mess when you try to use them.

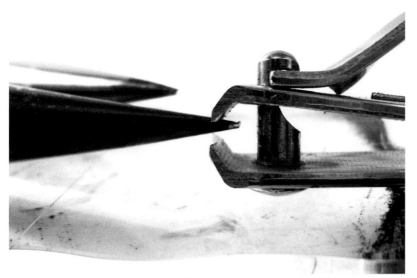

Use a nail clipper to clip the end of the cone. Removing this much of the Mylar will create a fairly thick line. Remove about half this much for a thinner line.

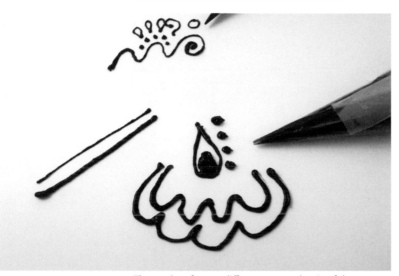

The results of a two different cuts at the tip of the cone. A smaller cut gives a thinner line, as shown on the top example.

CLIPPING THE CONE

Once you have made and filled your cones, you'll have to clip the tip of the cone so the paste can flow freely. I always have several cones on hand with various sizes of openings at the tips. Having options at my fingertips makes the tattoo application go much faster and allows me to be more creative on the spur of the moment.

For a fine line, just whisper the end of the cone off with the clippers. Try the cone out on a piece of paper. If you clipped too much to get the kind of detail you're hoping for, use this cone to shade larger areas or create a thick outline or border for your designs. Then clip another cone by taking off a smaller amount than you removed from the first one.

HENNA PASTE REMOVAL

The simplest way to remove the henna paste after the appropriate amount of time has passed (as little as 2 to 4 hours, but 12 to 24 hours if possible) is to just let it crumble up and fall off on its own like an autumn leaf falls from a tree in due time. But this is not the tidiest method. Like the leaves on a tree, the paste does not all fall off at the same moment in time. A method that is much cleaner and easier to tolerate is the "craft glue method" of paste removal.

HENNA TATTOO TIMELINE

Henna tattoos—from preparing the paste to allowing the paste to dry— take time. Plan ahead for the best results.

Day 1: Make the paste and allow it to rest.

Day 4: Place the bag on a white piece of paper. If the bag leaves a shadow after 15 to 20 minutes, it's time to apply the paste.

Day 4: Apply the paste. Allow it to remain on the skin for at least 2 hours. Longer is always better. Don't wash the tattooed area for at least 24 hours. For objects, allow the paste to dry for 3 to 5 days.

TIP Want to give your henna tattoo a little more dimension? Make a wash of half water and half henna paste, then apply it to the skin prior to applying the tattoo. The lighter stain of the wash will give the tattoo a two-toned effect. You can also outline the tattoo first then use a wet brush to pull color to the inner area of the tattoo for a watercolor effect.

THE CRAFT GLUE METHOD OF REMOVAL

While I am certain there are as many suggested ways to remove henna paste as there are techniques for applying it, I have found that the craft glue method is the single most tidy and tolerable technique to do so. All you need is a bit of children's non-toxic, hypo-allergenic water-based craft glue found in most local craft stores. Place equal portions of the glue and clear tap water in a small container or bowl. Mix the two ingredients well; it will be quite thin.

After you have applied the henna paste and it has set up to the point where it is no longer shiny and will not easily move when touched, carefully brush the glue wash over the entire tattoo with a soft bristle brush. It is important that some moisture is still present in the paste. You can add some glitter to the glue wash before you apply it to add a little sparkle to your tattoo; the glue will dry clear.

Allow the glue wash to dry, and leave it on until the wash begins to lift off on its own at the edges (about 2 to 4 hours). At this point you can peel up the glue wash and remove it very much like a bandage (without the ouch factor of bandage adhesive!). The best part of the craft glue method of henna paste removal is that the glue lifts off easily, taking all the henna paste along with it in one clean continuous motion. Just toss the refuse away—no mess, no fuss.

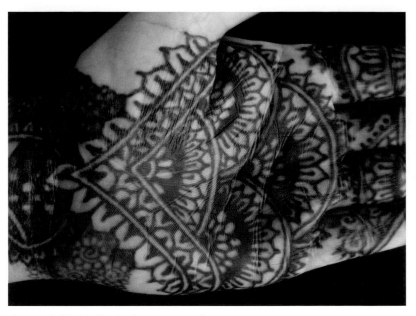

The stain left behind by the henna paste will continue to darken over time. This photo shows the depth of the stain at 24 hours after paste removal.

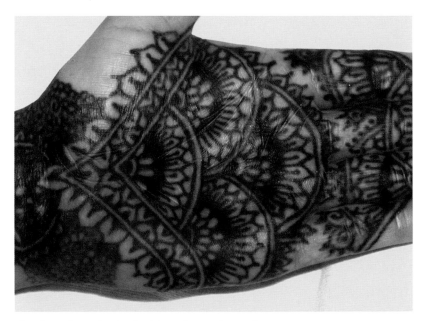

This photo shows the depth of the stain at 72 hours after paste removal.

TIP Always work in tiny increments—smaller than you think necessary—when you're clipping the tip of your cone. You can always clip again, but you can't put it back if you cut too much. If you mess up, simply squeeze the contents of the unusable cone into the new one. No reason to toss out the henna paste with the bad cone!

PRACTICE

The great thing about henna tattoos is that even a very simple design can look intricate and complex when complete. Take, for instance, the common flower. You will see flowers used in henna tattoo designs all the time. Almost all flowers begin with the same stroke: a simple circle. The tricky thing about applying henna paste is not the artistic aspect as much as it is retraining the muscles in your hands to do something they likely have not done before.

Applying henna paste looks as if it should be very easy—after all, you're holding the cone very much like a pen. It should be like doodling at the very least, right? Unfortunately, it isn't. The cone requires more hand-eye coordination because you have to know when and how much pressure to apply while you're making the artistic sweeping motions of the tattoo. The best way to get your hand familiar with the process is to practice.

HENNA TATTOO SHAPES

Five base figures make up the more common elements of Mehndi-inspired henna tattoo designs:

- Circle
- Petal
- Leaf, or Spire
- Curlicue, or Question Mark
- Straight Line

The best way to practice is on a piece of paper. Let's start with the circle.

First, draw a basic circle on a piece of paper with a pen and clip your cone to a fine point (see Clipping the Cone on page 21). Then, using the henna cone, make the same circle over and over again on the paper. You will soon become comfortable with the henna cone and the amount of pressure to apply. This repetition is how you train the muscles in your hand to do what you want.

Practice each of the five strokes on a piece of paper until you can make them consistently. If you master these strokes individually, you will do just fine making some very beautiful henna tattoos.

Enough reading, right? Are you making those shapes in good, consistent fashion? Then let's get going on the tattoo practice part.

THE BASIC FLOWER

Look closely at this basic henna flower tattoo. The five strokes you just practiced are used to make this common pattern.

Most henna tattoos begin with some variation of these five strokes. Your tattoo designs are only limited by your imagination and how you put the strokes together to create beautiful images.

It's a bit of a curiosity, but for some reason to create artistic balance in the completed design, you should use odd numbers of objects. That is to say, one flower or three for a group, rather than two or four.

> **TIP** Working with a henna cone to create tattoos is very similar, in my mind, to the art of cake decorating. With practice, your hand will soon respond to your desire to create specific shapes using this new tool. It may seem boring, but practicing the basic shapes until the muscles in your hand become trained is essential.

HENNA TATTOO SHAPES WORKSHEET

Make a copy of this page and practice using henna over the shapes.
You'll be confident in your abilities to freehand the designs in no time!

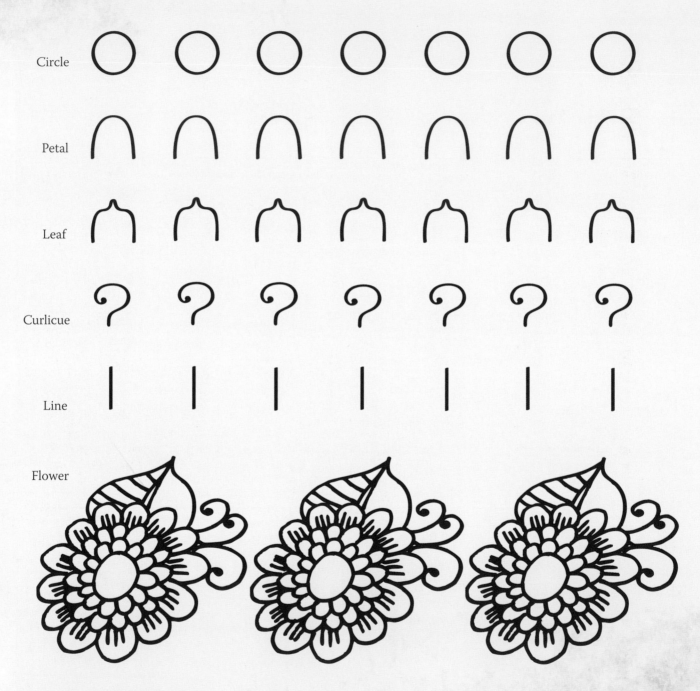

Circle

Petal

Leaf

Curlicue

Line

Flower

Put all five of the basic shapes together with
the flower design.

PRACTICING THE BASIC FLOWER

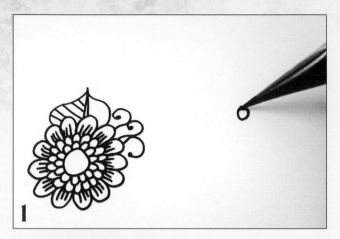

1

Start the flower with the circle.

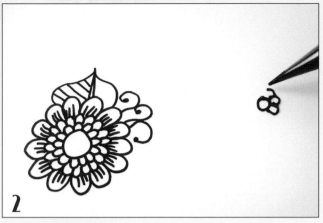

2

Continue by making repeated petals (upside down U shapes) all around the circle.

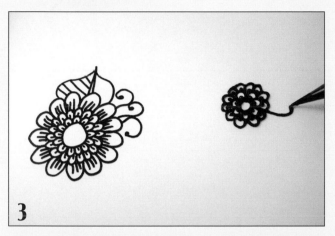

3

Add a single dot inside each petal for further definition, then start on the larger version of the U-shaped petals.

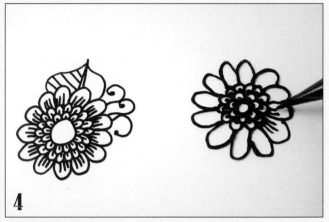

4

Add a few straight lines inside the bigger petals. Like the dot in the smaller petals, this line adds definition and complexity to the final design.

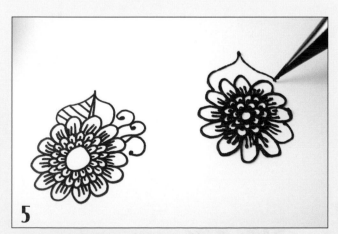

5

Next add a leaf. Inside the leaf add the straight lines. To finish, add a small grouping of curlicues.

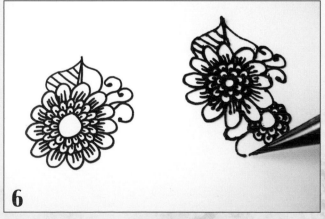

6

You could stop there and have a perfectly beautiful tattoo design. Or you could add another flower by repeating the same steps over again.

Henna Body Tattoos

Human skin makes an ideal canvas for henna tattoos. Because of the nature of henna paste, the resulting dye does not leave a permanent mark on the skin, allowing you to try various designs based on your own whims or according to special events you have planned for that month. Let's get started with your first tattoo, a classic flower that incorporates all the basic lines you learned; then, we'll move on to the more intricate tattoo designs for your hands.

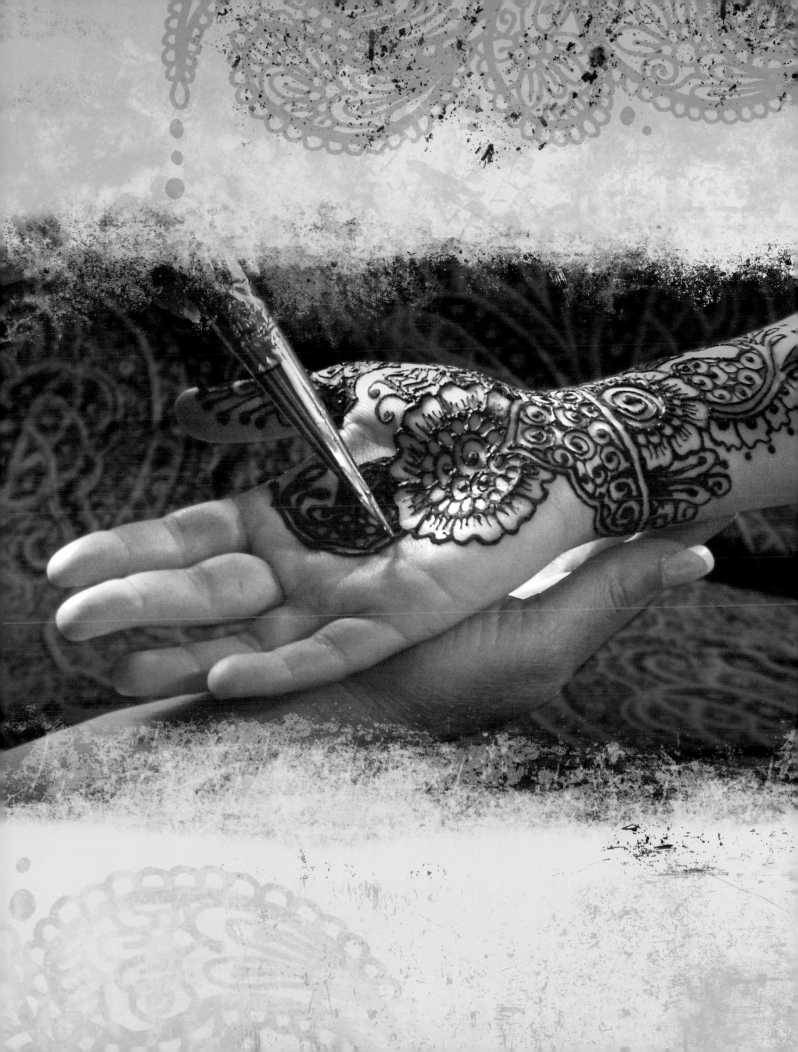

YOUR FIRST TATTOO

{ **SKILL LEVEL:** 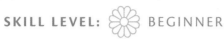 BEGINNER

Let's go to the palm of your hand for your first tattoo. Why the palm? Simply because it is close. You can see what you're doing without contorting your arm or leg, and you can still protect your work somewhat from public view by simply keeping the palm of your hand to yourself.

TIP Don't want *anyone* to see your first attempt at tattooing yourself? Instead of working on the palm of your hand, work on the soles of your feet. They are invisible to others, making them the best place to practice your new skill—although they may be a little hard to reach.

Use the same flower image that you practiced earlier (see The Basic Flower on page 25). It is always a good idea, especially when you are just starting out, to practice drawing the tattoo on paper first with the henna paste and cone.

For your first—or every—tattoo, here's a trick you can use to get a perfect pattern on the skin before you place the henna. Go to your local craft store and purchase a brown-toned watercolor pencil. Dip the pencil in water and draw your design on your skin before you tattoo. If you don't like what you see, simply wipe off the pencil marks and try again. When you have the image the way you want it, tattoo right over the drawn sketch.

Mistakes with the henna cone are bound to happen. If you make a mistake, use a damp cotton swab or tip of a toothpick to remove the stray henna. If you want to wipe off the henna and start over, use alcohol wipes from the drug store or a cotton ball moistened with alcohol. The alcohol evaporates fast and seems to retard the henna stain development.

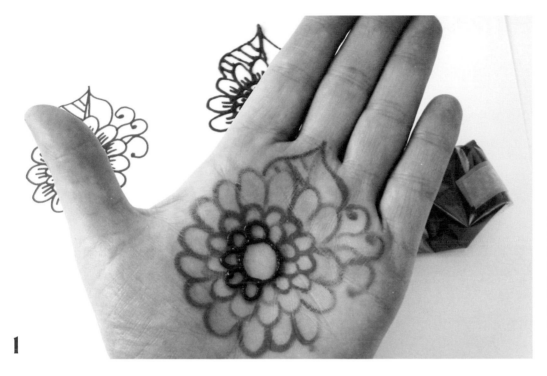

1

Begin with a circle. Here you can see the watercolor pencil I used to draw the original design on my palm. Begin with the circle stroke, move on to the petal shape, and finish with the leaf, following the lines with the henna cone.

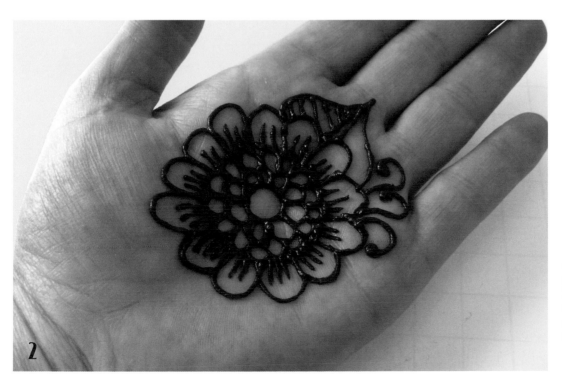

2

Allow the paste to remain. When complete, let the henna dry, remaining on your hand for a minimum of two hours. Longer is always better.

FINGER TATTOO

SKILL LEVEL: ❀ INTERMEDIATE

Our second tattoo design looks more complex, but as you can see from the highlighted area in the photos, the same common strokes from the basic henna flower are used here. However, instead of showing the full flower, we will draw only half the design—as if the rest is hidden behind the gently curving line that extends from wrist to finger tip—and repeat it along the length of the curvy line.

TIP Try not to wash the tattooed area for 24 hours after the paste has been removed. For tattoos on the hands this can be tricky when you live an active life! But if you can manage it, the tattoo will last longer. One idea that works for me: do the tattoo right before bed.

If you are not comfortable with freehanding the henna paste directly on the skin, practice on paper first or draw guidelines on the skin with a brown-toned watercolor pencil. This design is labeled as intermediate skill level because of the need to keep the paste flowing smoothly from the tube for the entire length of the wrist and hand.

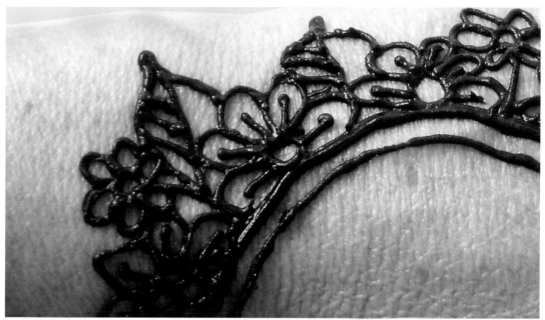

The complexity is somewhat of an illusion. Notice how this design is made up of the same five basic lines used in Project 1.

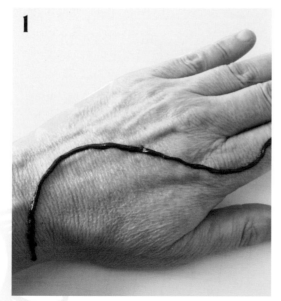

Start near the wrist. I started at the base of the line near my wrist and worked my way up the curve.

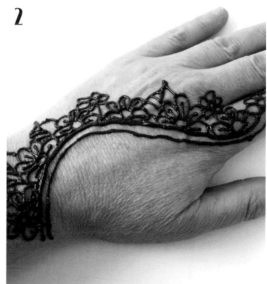

Repeat the design. Repetitive simple flowers form a cluster design, turning simple individual objects into a much more complex tattoo once completed.

LACE GLOVE

SKILL LEVEL: ● ADVANCED

For our last tattoo project, let's try something more intricate. Again, if you look closely at the design, you'll see that the lacey look of this tattoo was created with a series of simple repeated shapes, much like our first tattoo. This project is advanced because it requires more control to make the many evenly spaced lines and curves. As always, warm up by practicing on a piece of paper first.

TIP Henna tattoos need a humid environment to "take." A recipe that works perfectly in steamy Florida might not react so well for someone in the drier regions of Arizona. Try adding more sugar or honey to encourage the paste to stay in place longer, or wrap the tattooed appendage in plastic wrap when the henna is dry.

Try to work in a natural progression down the length of your hand. It is important that the lines remain as consistent as possible. Inconsistent lines will result in a tattoo with lines that are not sharply defined, which will make the tattoo look a bit sloppy.

Allow the henna paste to stay in place for a minimum of two to four hours, or 12 to 24 hours if possible, then remove it (see page 21). Bravo! Your delicate henna lace glove is ready to be shown off to the world.

1. Begin at the peak of the lines above the wrist. Start with the double lines above the wrist. Note that the line closer to my fingers is made with a thicker applicator cone. Start to add the half moon shapes, petals, and dots that form the portion of the design at the point of the lines.

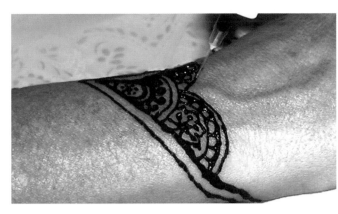

2. Continue adding scale-shaped areas to fill in. Make a double line to separate one portion of the design from the next, then continue on. The top part of this design is created by linking together three sections of the same repeating pattern.

3. Draw a large pointed teardrop shape on the back of the hand. Open up the central part of the design by outlining a pointed teardrop shape on the back of the hand. Because the final bit of the design spills down the middle finger, you'll want to make sure that the point of the teardrop is in line with the center of the middle finger. Add a few simple curves and circles inside the space you created.

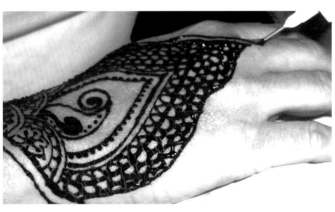

4. Expand the edges of the design with repeating patterns. Working from the top down to the point, add as many rows of half circles or other repeating design elements as you need to fill the area between the end of the pointed teardrop and the knuckle of the middle finger.

TIP To keep the dried henna paste on your hand longer, mix equal portions of white craft glue (like Elmer's) and water, toss in some glister for a pretty distraction, then brush over the dried paste with a delicate stroke of a paintbrush. Best of all, when you peel away the dried glue, the henna paste comes off clean along with it. No scraping!

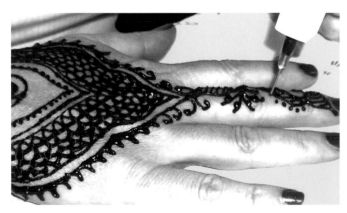

5. Add the final decoration down the center of the middle finger. Draw a central line down the middle finger and add leaves, petals, dots, and lines to complete the tattoo.

GALLERY

Using henna to create tattoos on human skin is a unique way to express your individuality in a not-so-permanent fashion. On the pages that follow, you'll find a number of examples of henna tattoos. Many of these designs follow Mehndi traditions, but you can use henna paste to draw geometric patterns, realistic objects, or lettering. Enjoy exploring your creativity with henna.

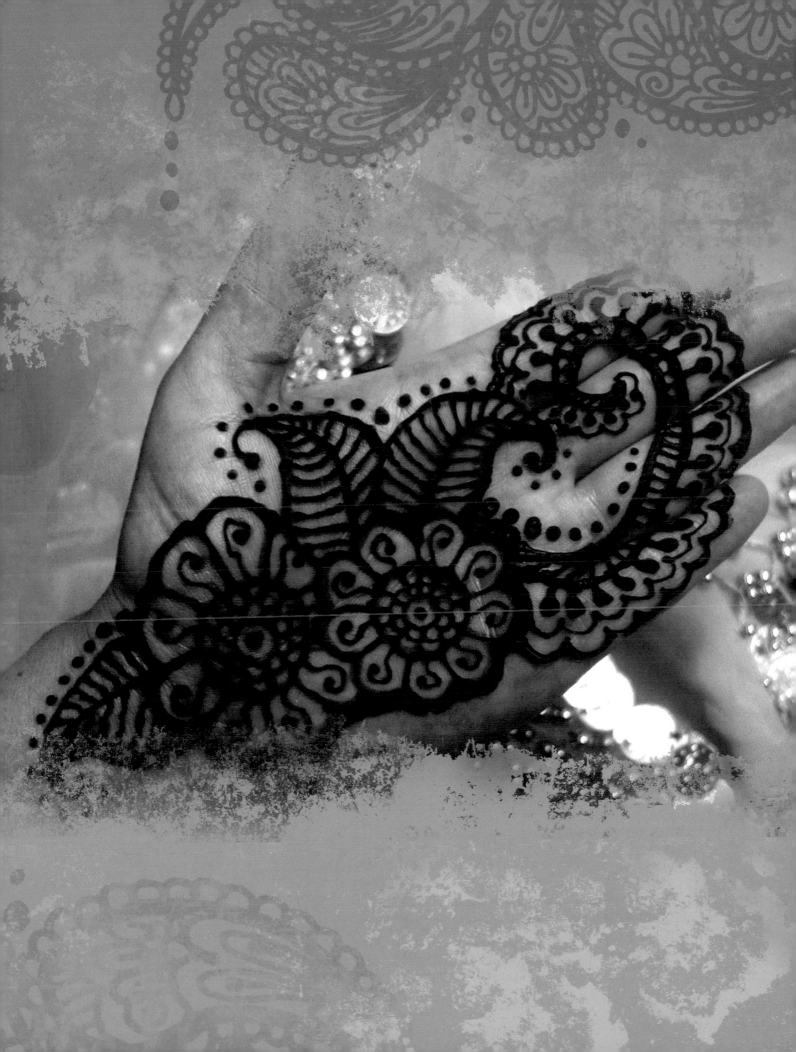

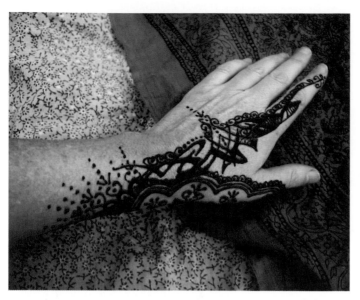

A geometric design that extends from the wrist to the tip of the first finger is balanced with softer curves that cover the palm of the hand.

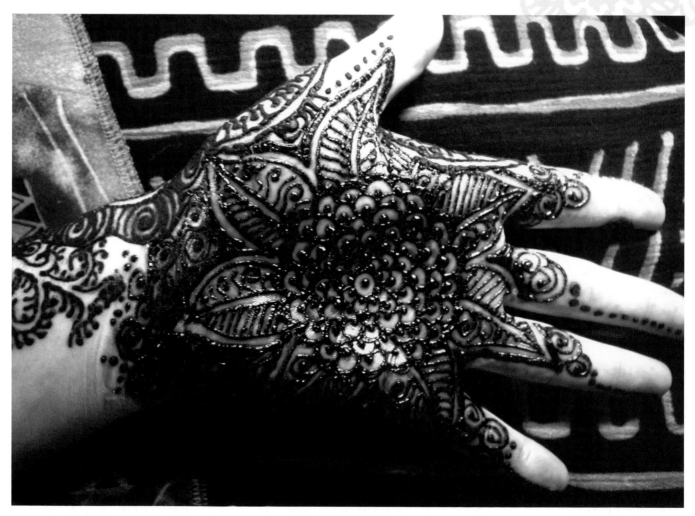

A dense flower center is surrounded by leaves on the palm of the hand. The shiny look is from the craft glue wash that was applied to keep the henna paste in place longer.

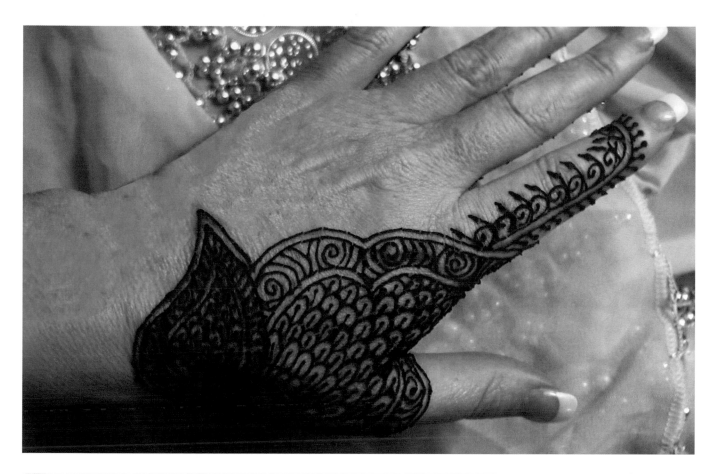

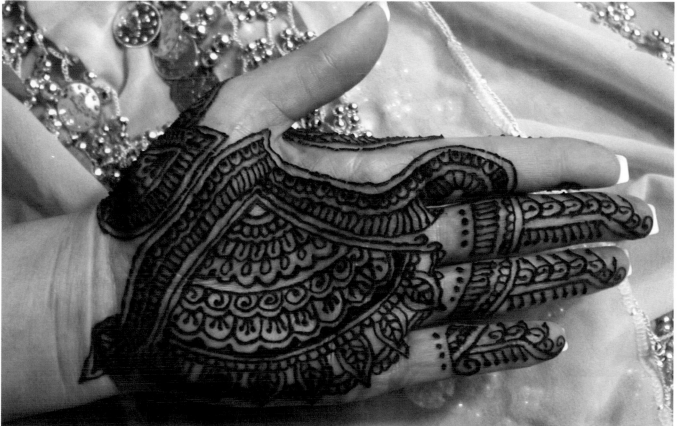

A design that starts on the top of the hand continues to the palm.

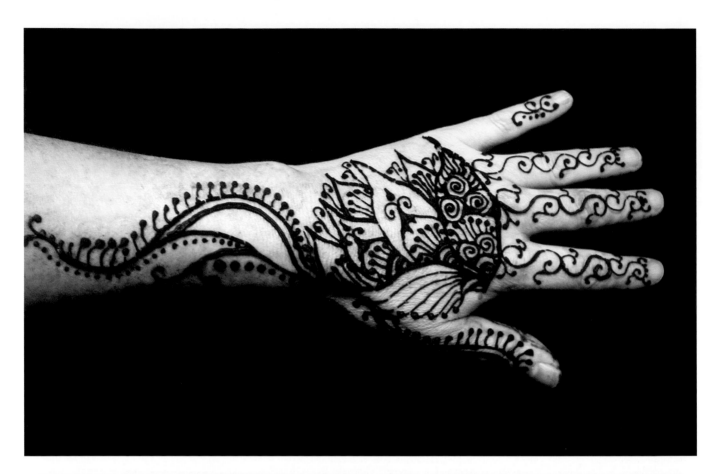

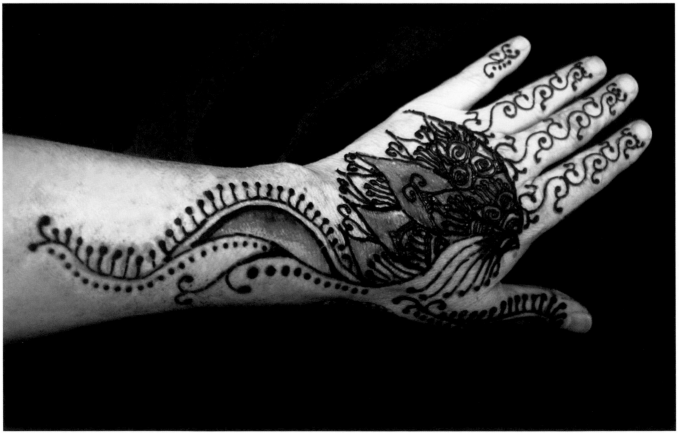

A henna wash made with half water and half henna paste gives dimension to some of the open areas of this design.

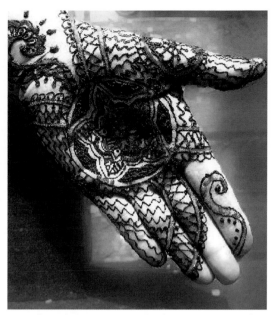

Zigzag lines draw attention to the dense central part of this henna tattoo. Colored paint gives the tattoo a little extra interest as the henna paste dries.

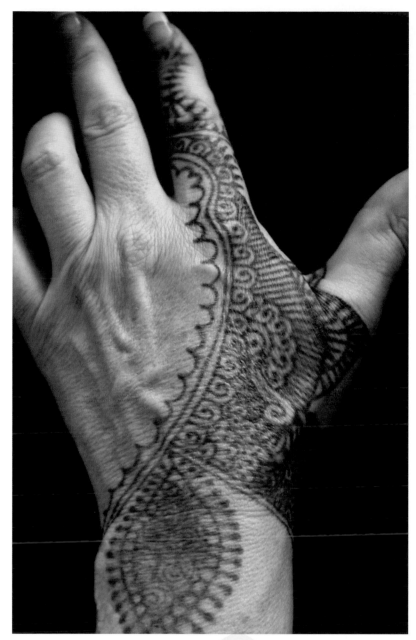

The strength of the stain varies depending how long it was left on. The darker areas of this tattoo were applied first.

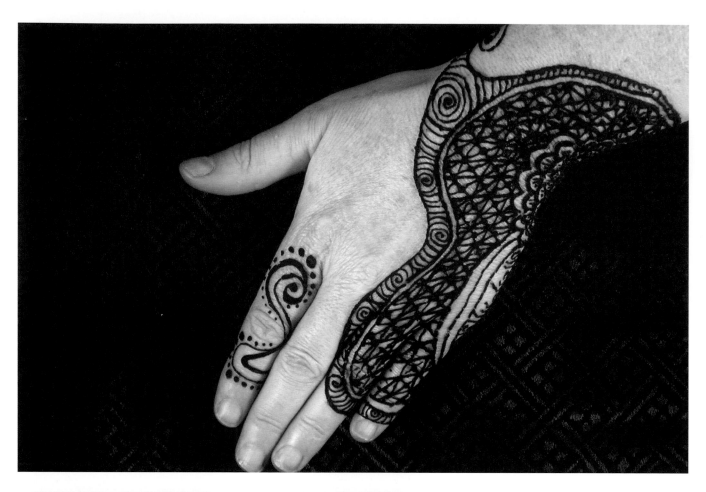

Designs do not have to be symmetrical and are often done freehand to complement the natural shape of the body.

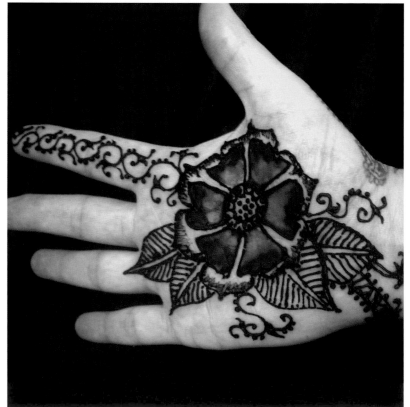

Large shaded flower petals with starkly lined leaves form a unique design for the palm of the hand.

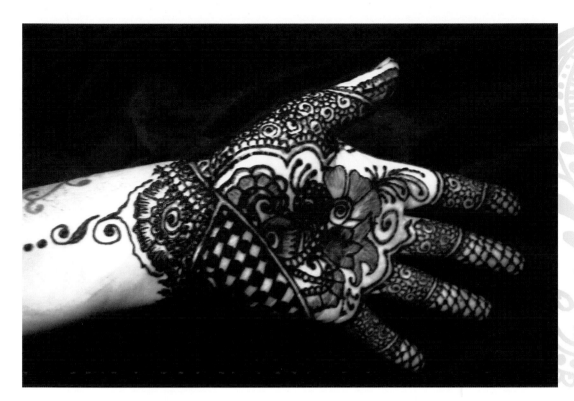

A henna wash is used to highlight and fill in the flower petals shapes on the underside of the hand.

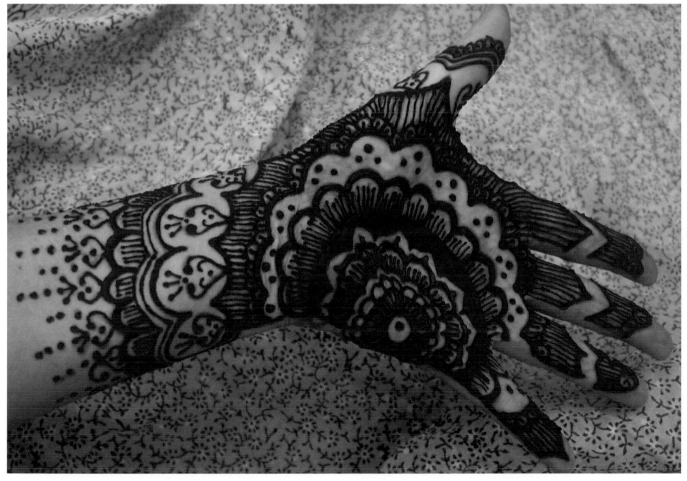

Designs extend across the closed fingers of the underside of the hand so that the areas between the fingers are left blank.

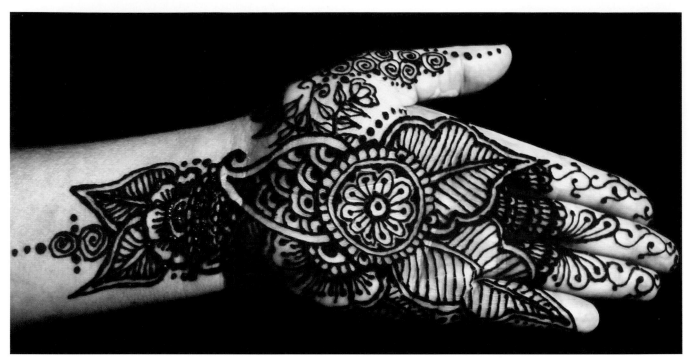

Leaf shapes extend from a central flower following the line of the fingers. Note that the henna design does not go between the fingers.

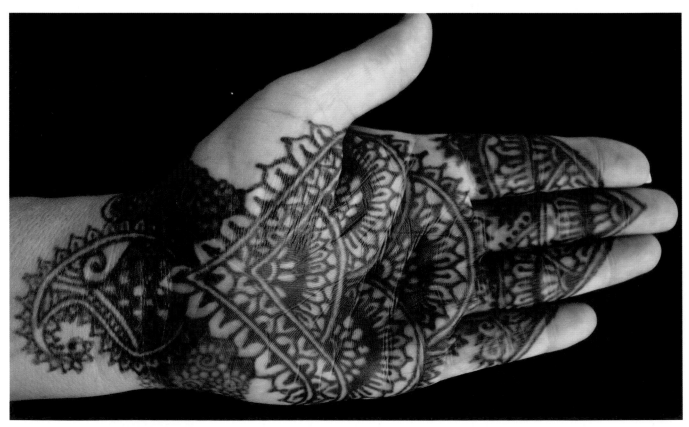

Once the henna paste is removed, a dark orange-burgundy stain is left in its place. The stain will continue to darken for about 72 hours. This photo was taken 24 hours after application.

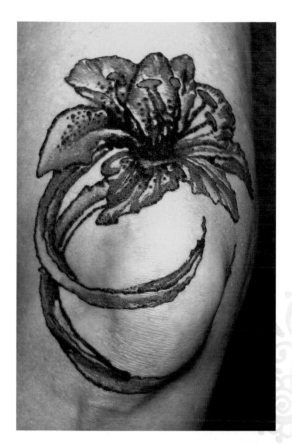

Henna tattoos look best when designed to fit the profile of the area being tattooed. This lily flower rests above the knee where it is easily visible when sitting or standing, while the leaves wrap below the kneecap.

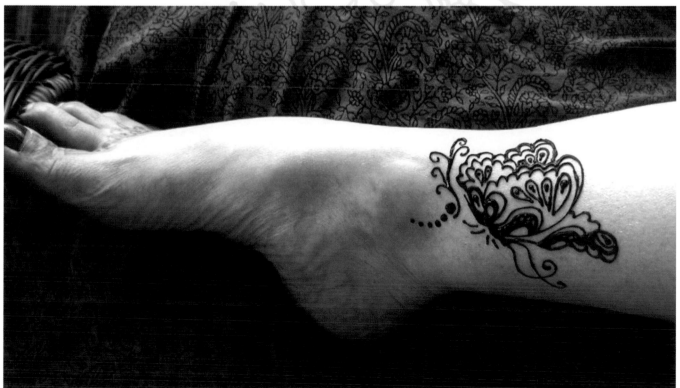

Small henna tattoo designs at the ankle can be reminiscent of ink tattoos.

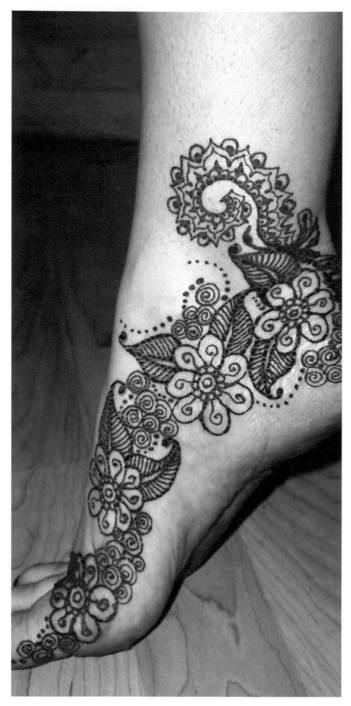

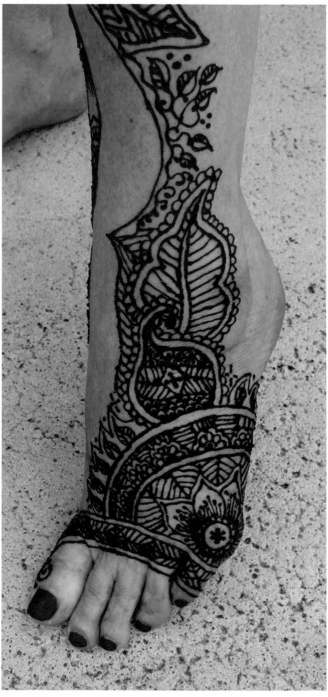

Remember the curlicue—one of the five basic shapes? It really takes center stage in this design. I also like the wispy look added by the chains of dots.

Henna tattoos can easily be extended from the tips of the toes along the calf.

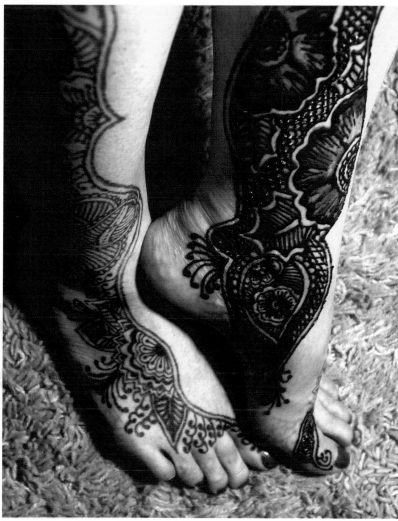

Henna paste can be removed after as little as two hours to reveal the orange-burgundy temporary tattoo left behind (left). Leaving the paste on longer, however, is always better.

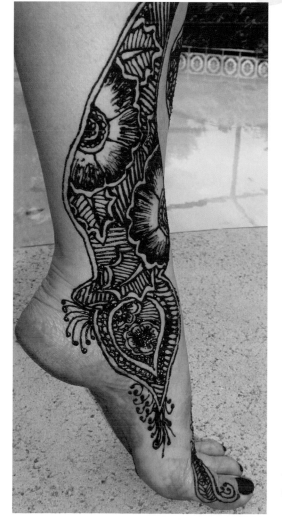

This tattoo was designed to echo the shape of the heel and the calf as it reaches up the leg.

DESIGNS AND TEMPLATES

As with new skills, the more you practice, the better you'll get. Here are a few original Bajidoo designs for you to try on as your talent grows. Some of the designs are simple, in the sense that they are made up of only the five strokes we covered in the beginning of this book. Some are more complicated, so when you are ready to venture on you have a design to refer to. I've also included a handful of templates for your designing enjoyment. Good luck and happy tattooing!

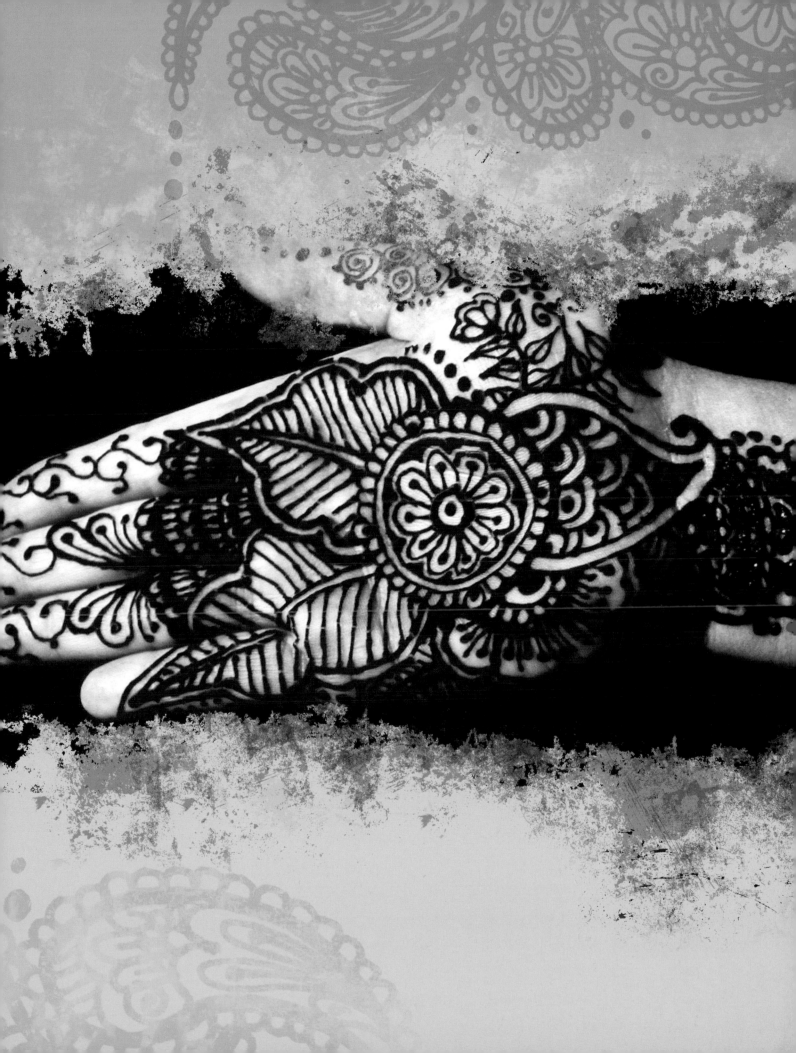

HANDS

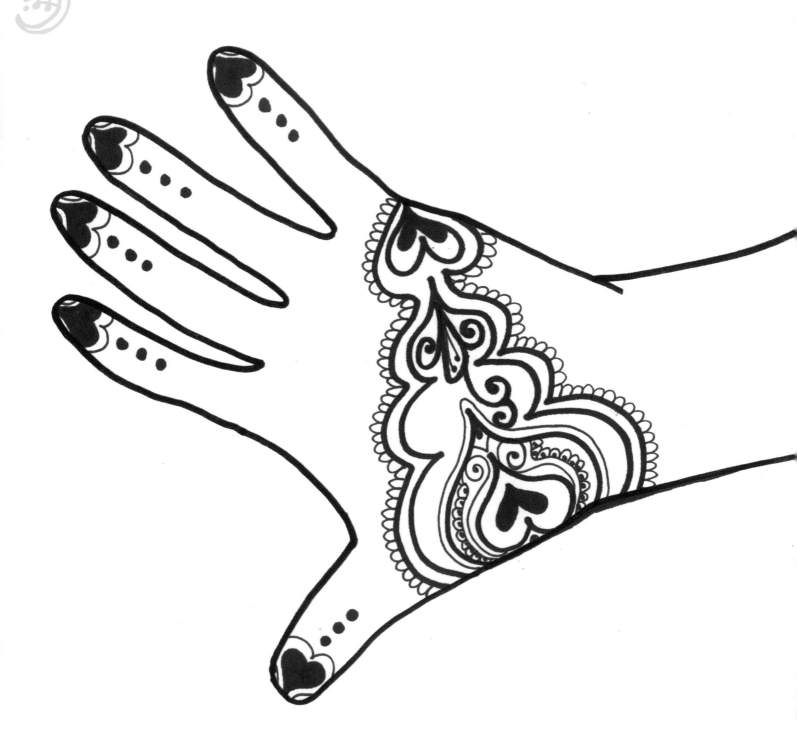

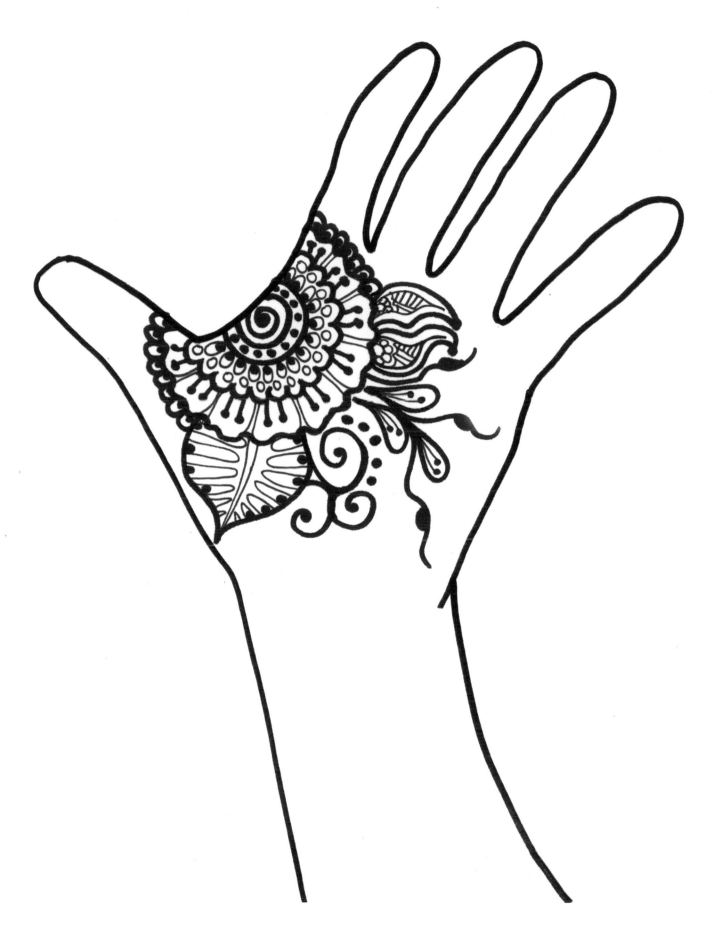

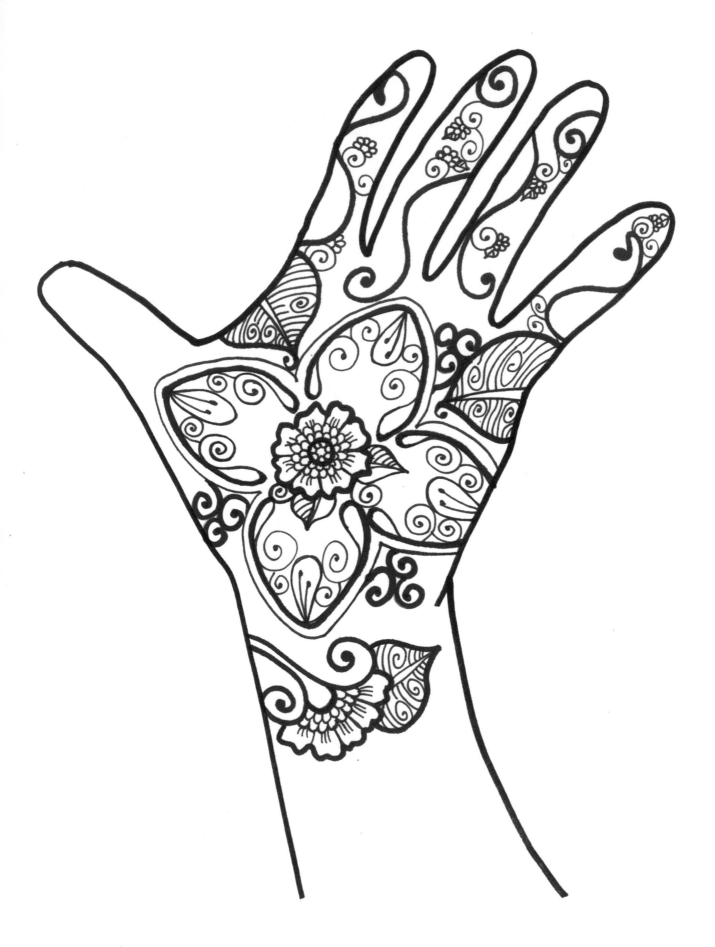

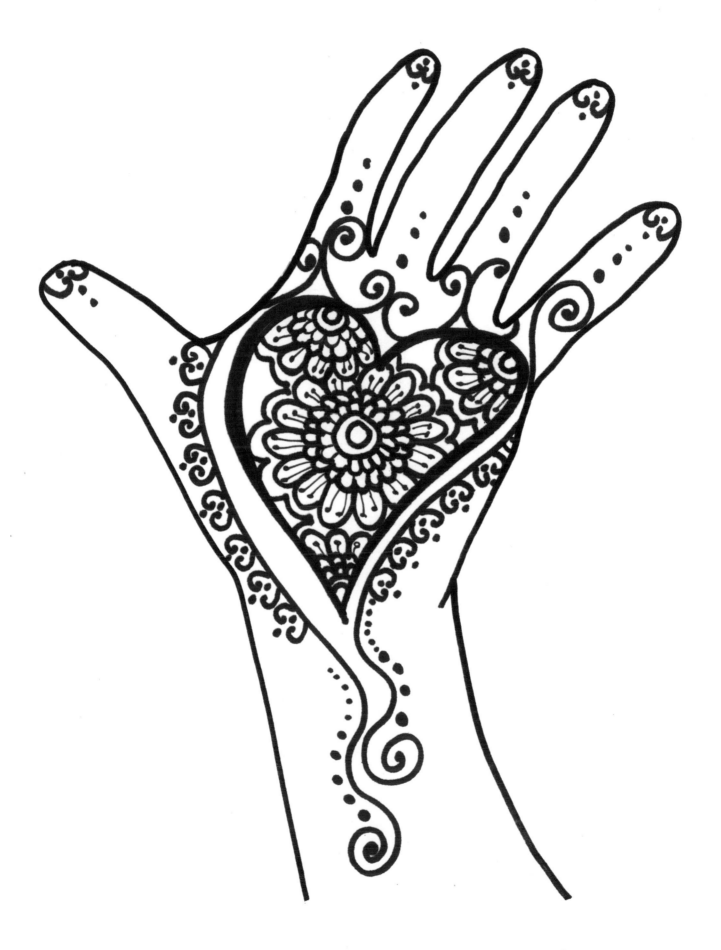

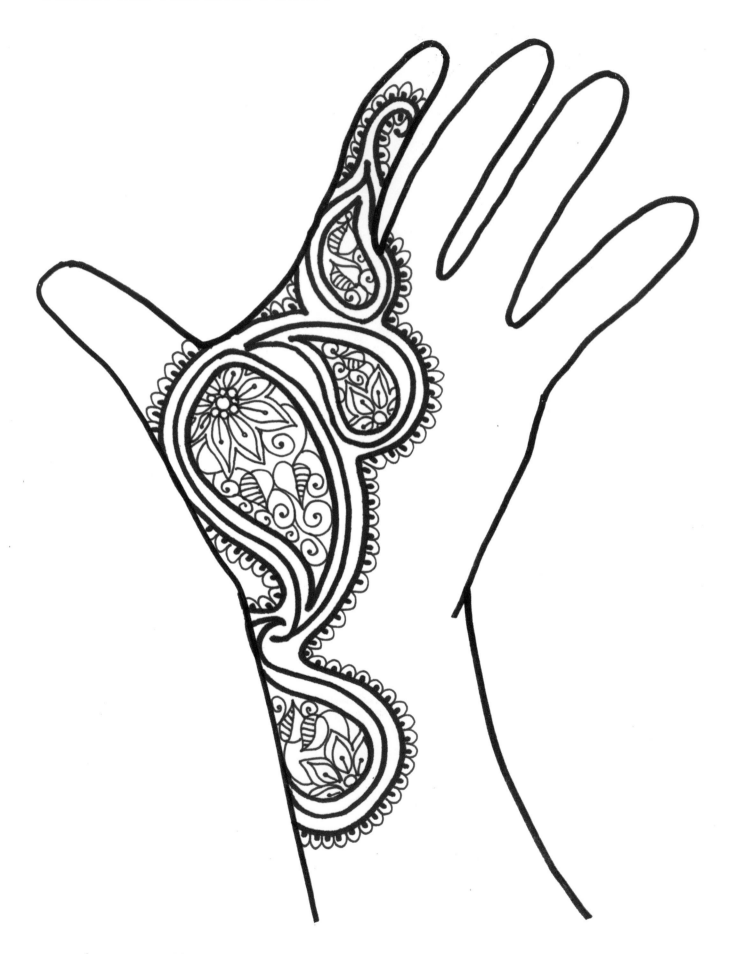

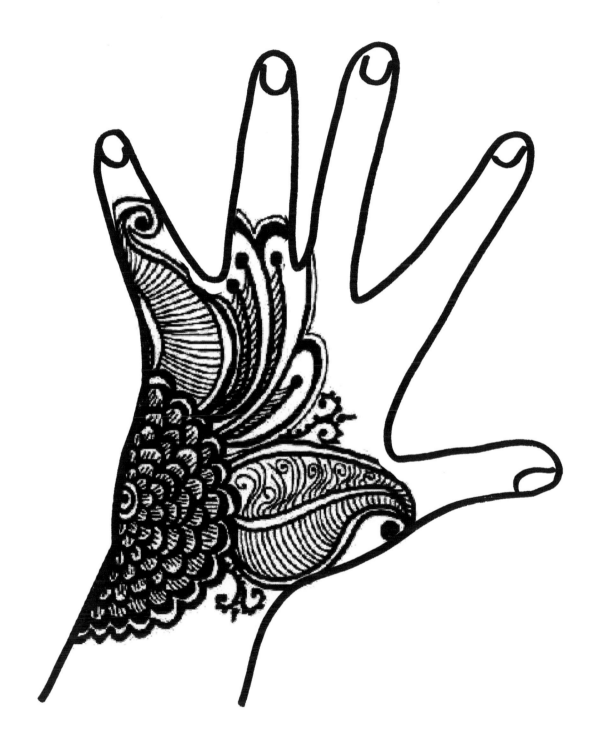

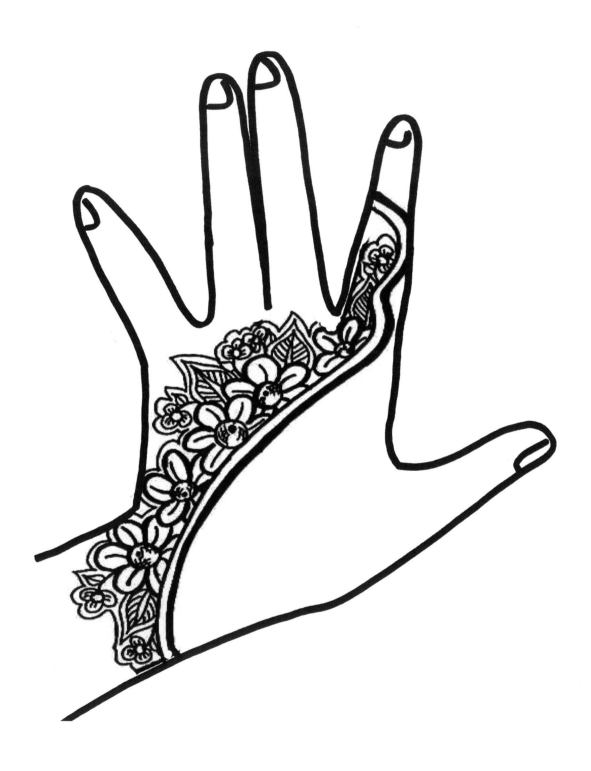

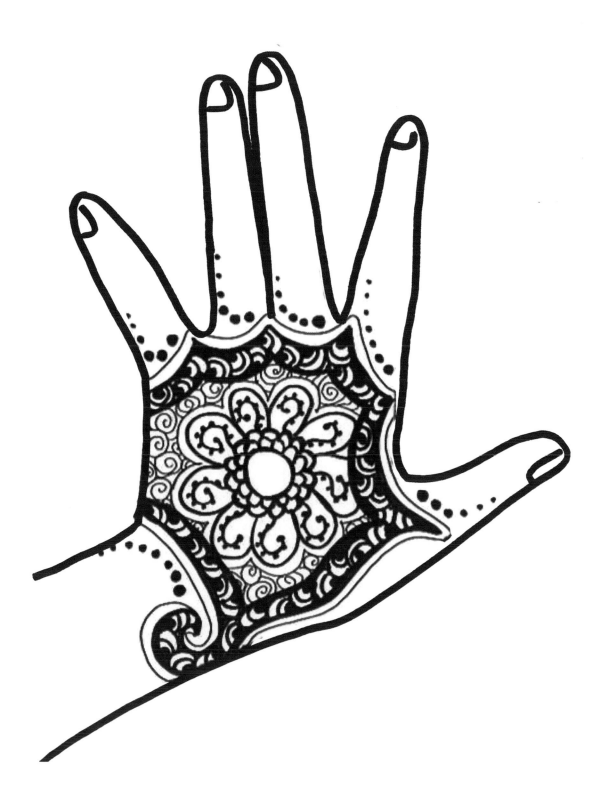

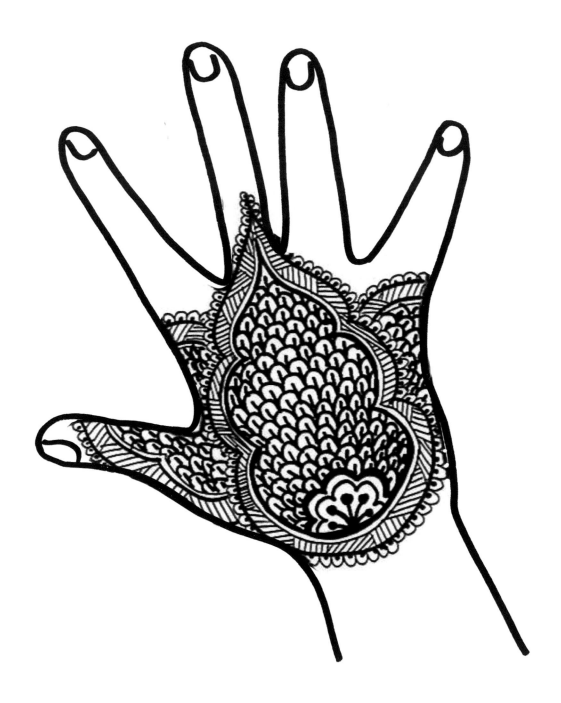

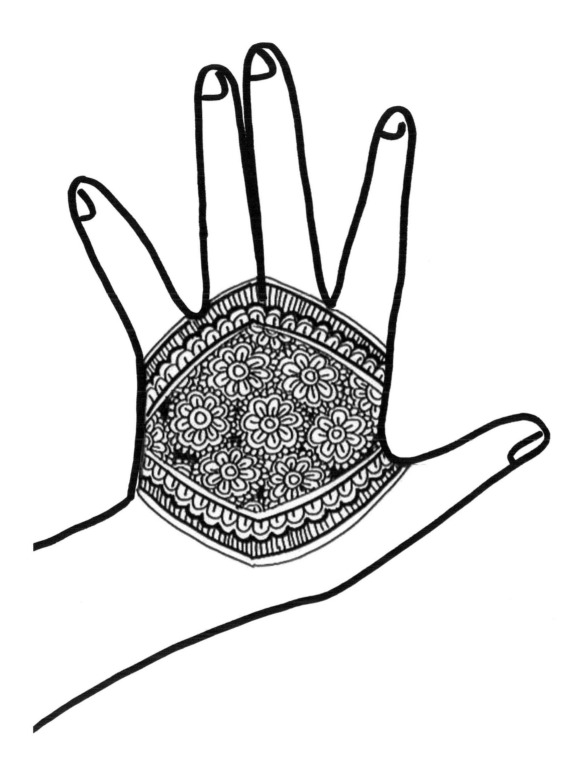

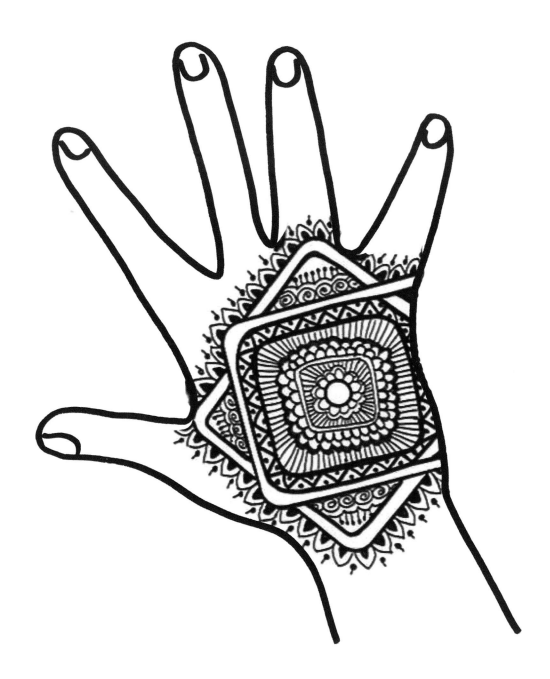

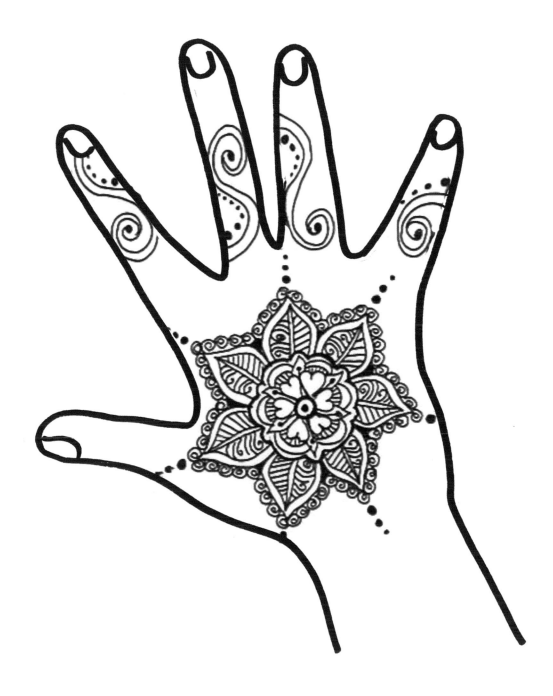

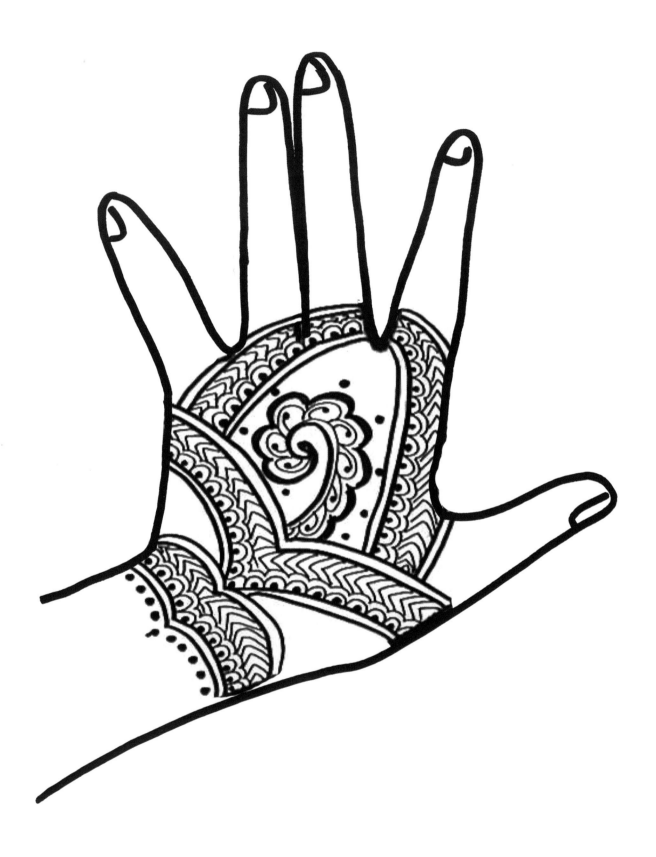

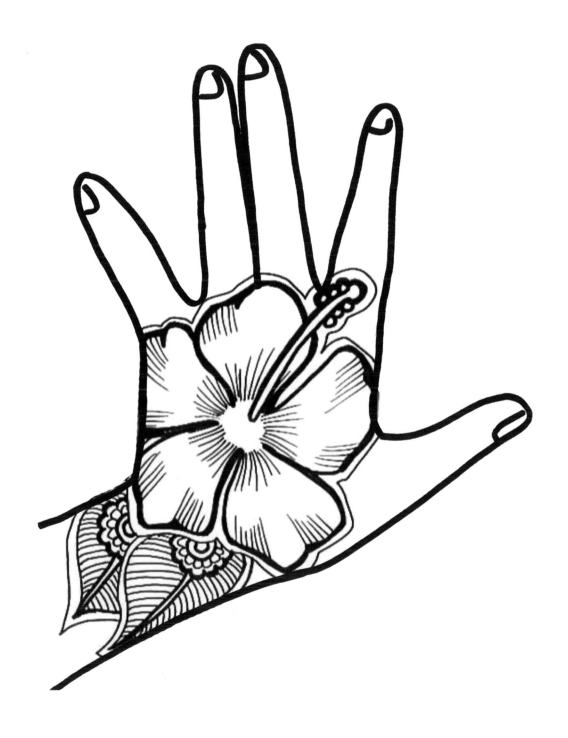

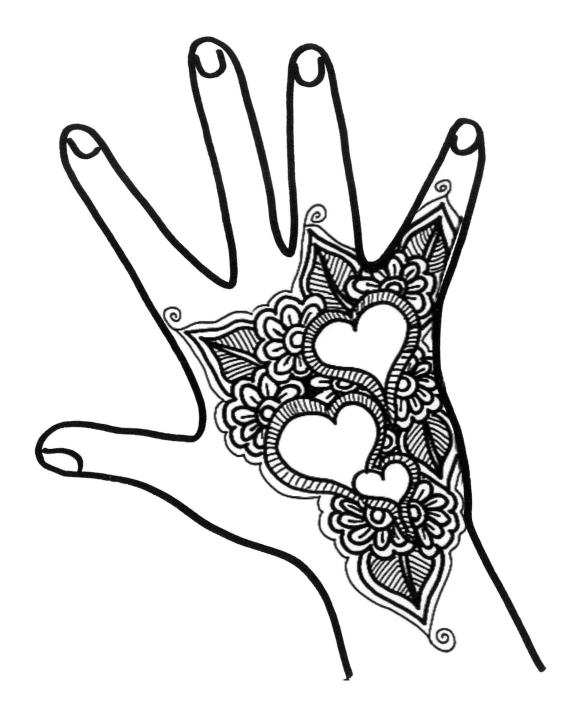

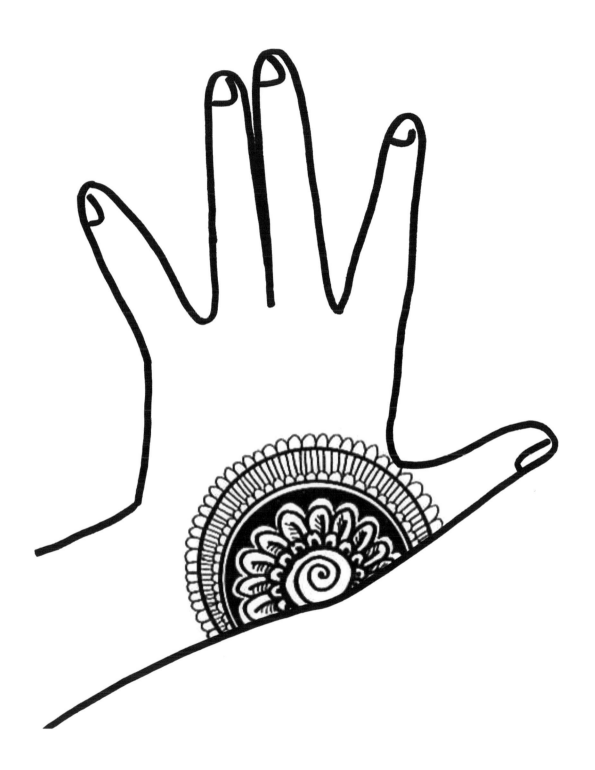

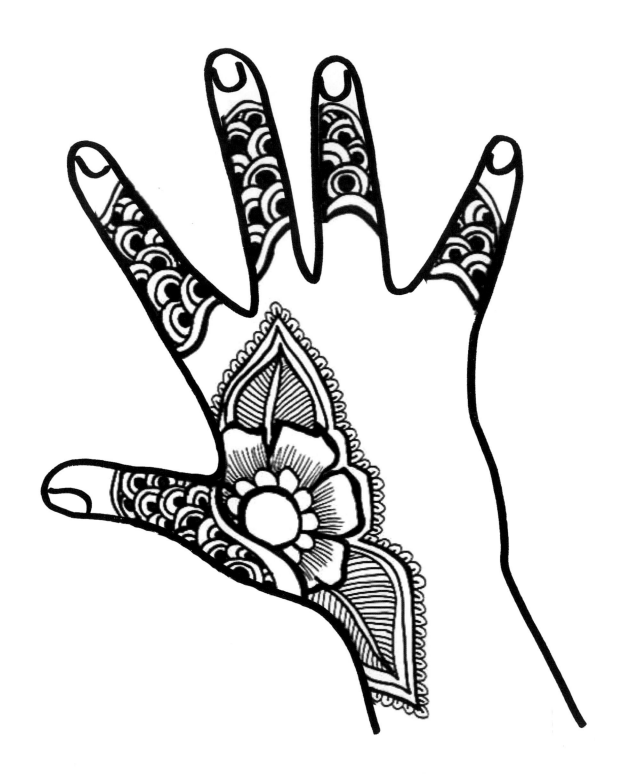

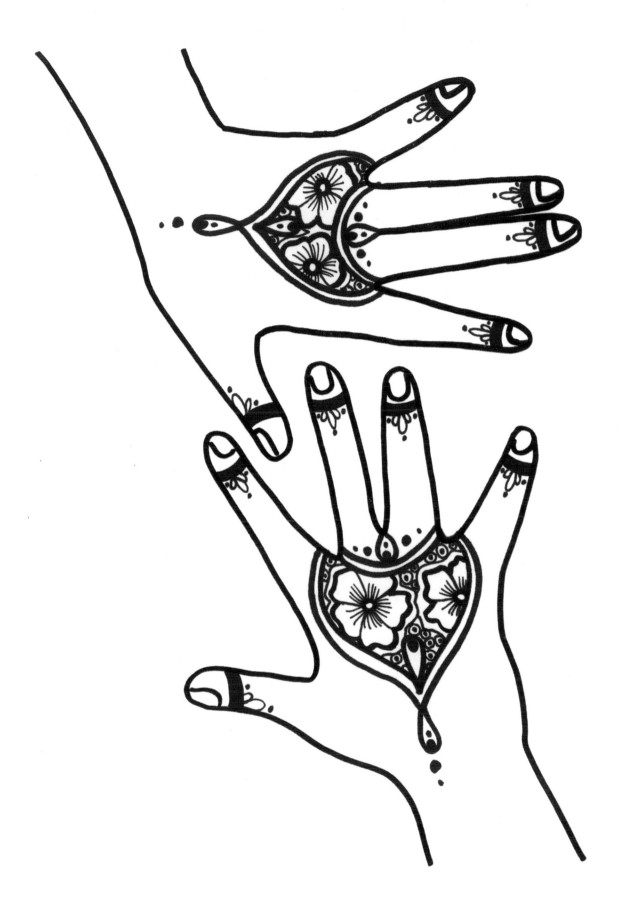

Teach Yourself Henna Tattoo

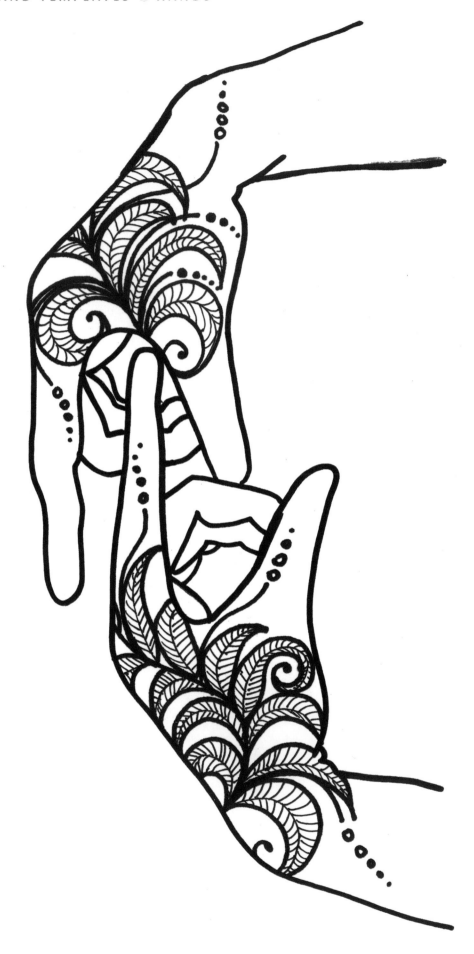

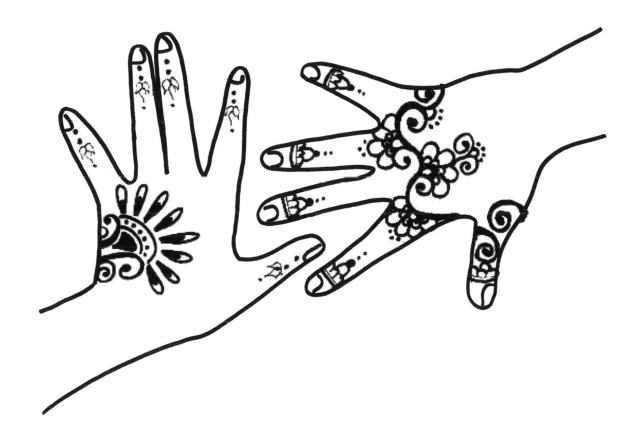

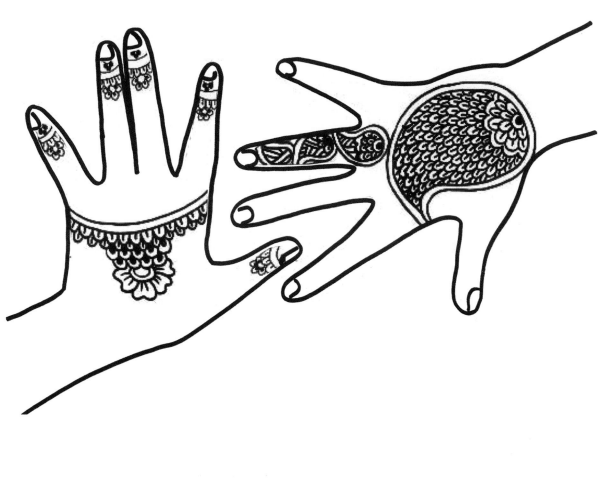

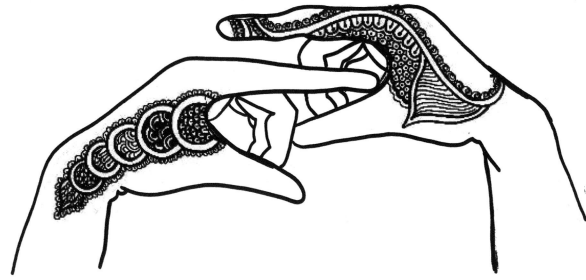

FEET

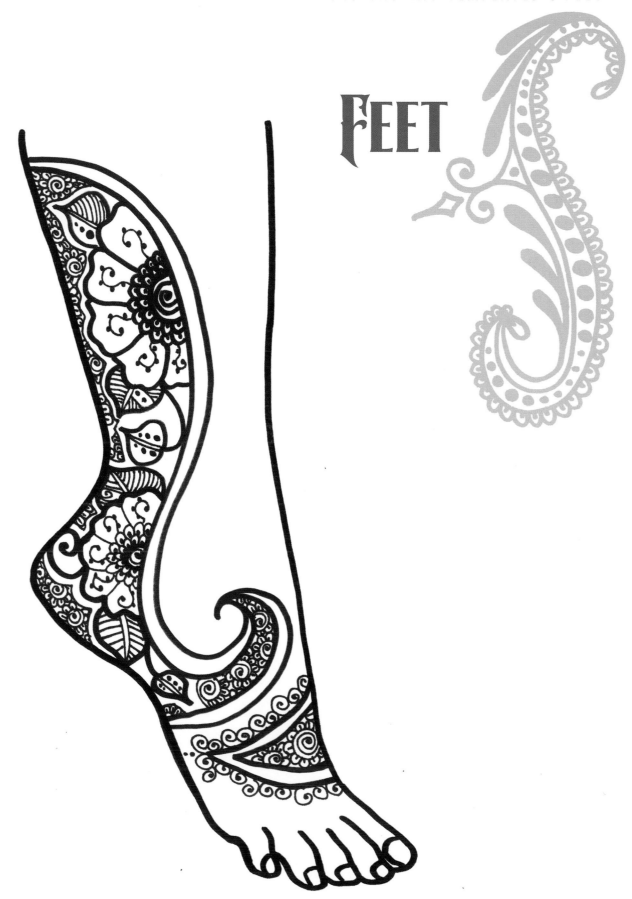

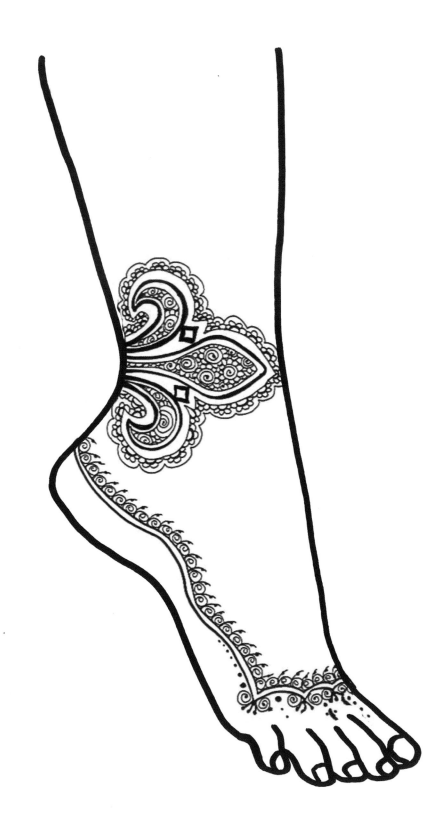

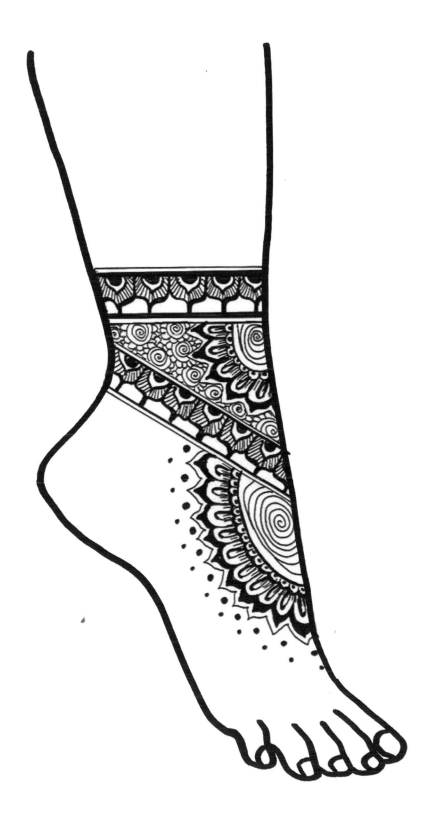

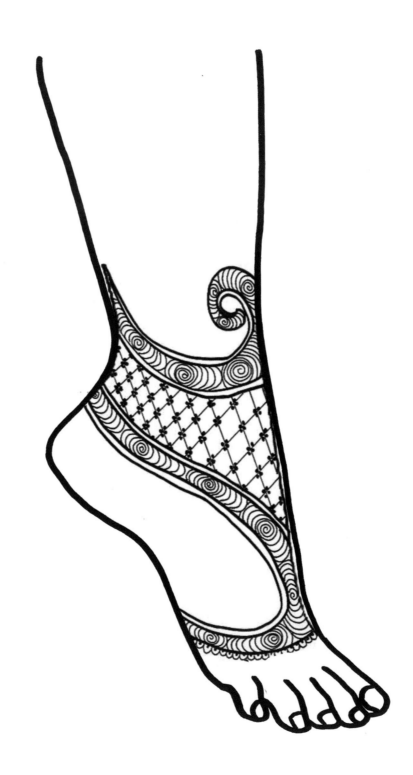

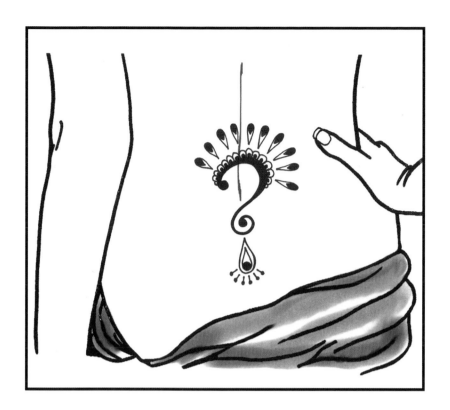

BACK

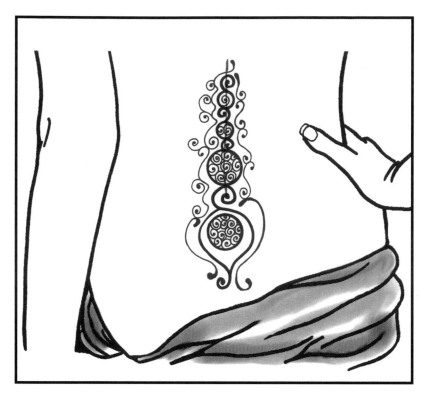

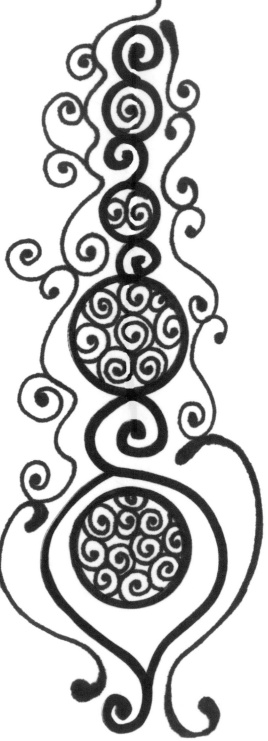

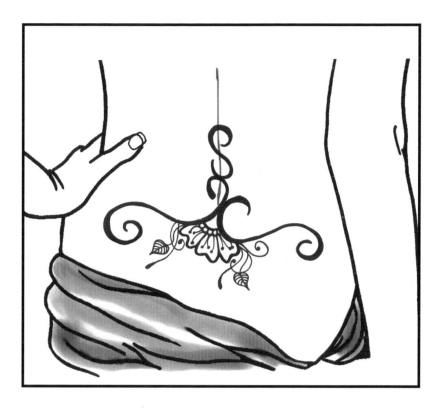

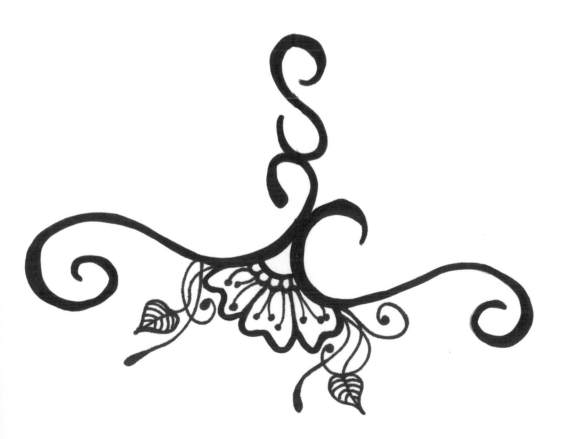

SHOULDER

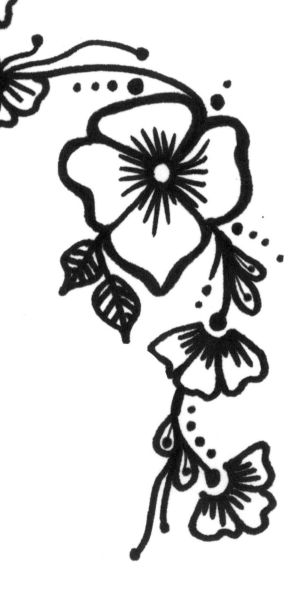

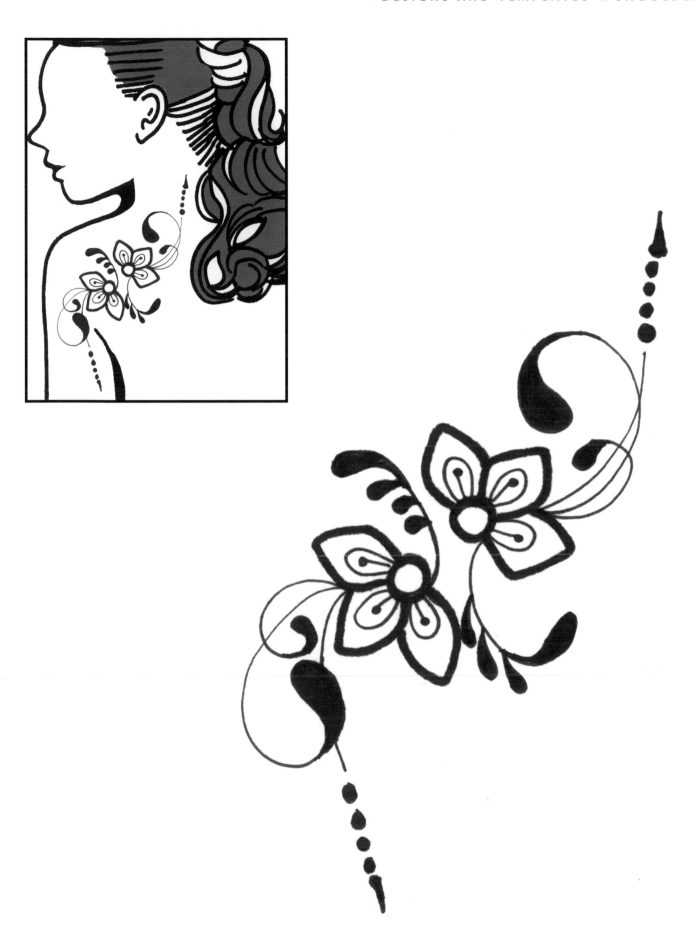

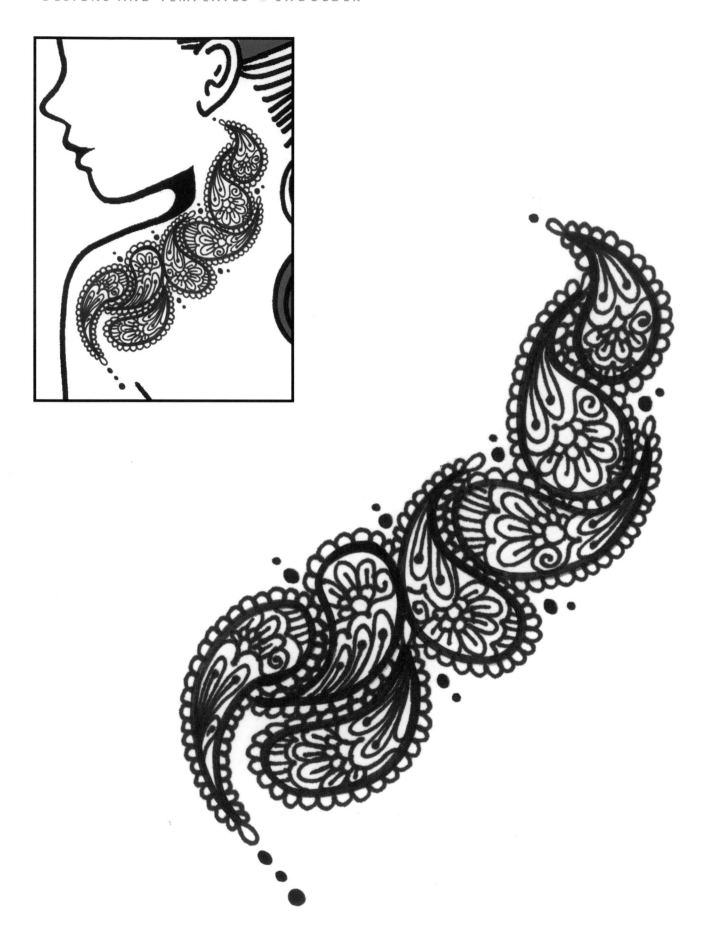

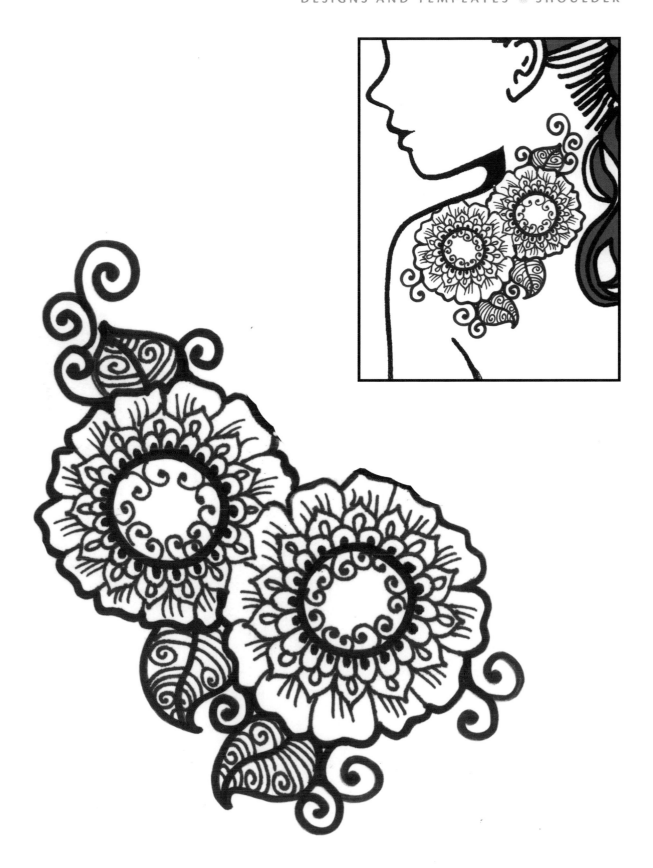

ADDITIONAL ELEMENTS

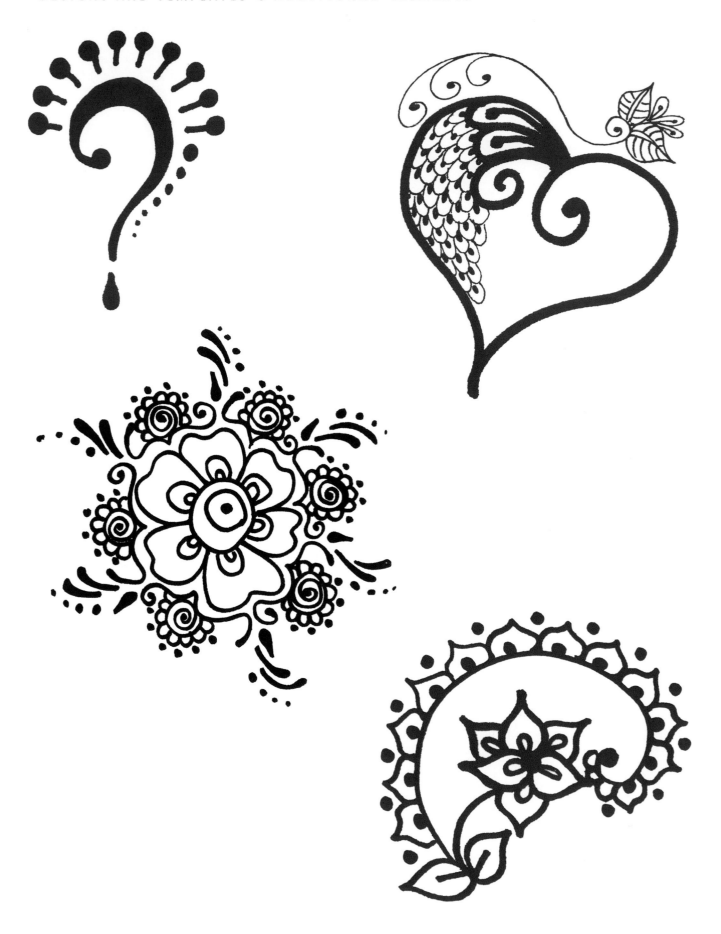

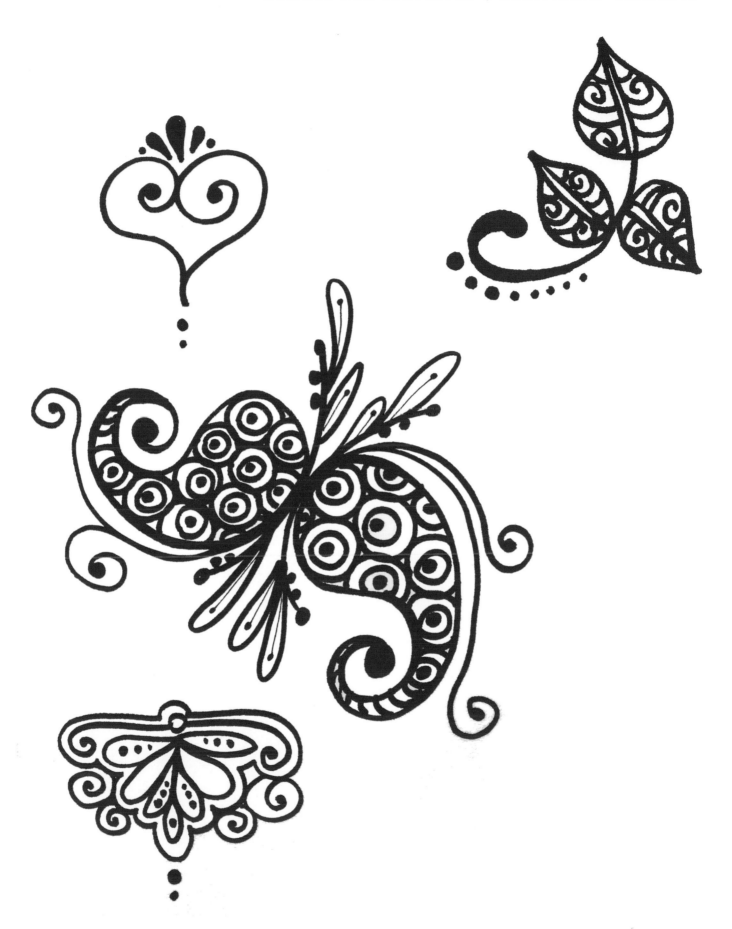

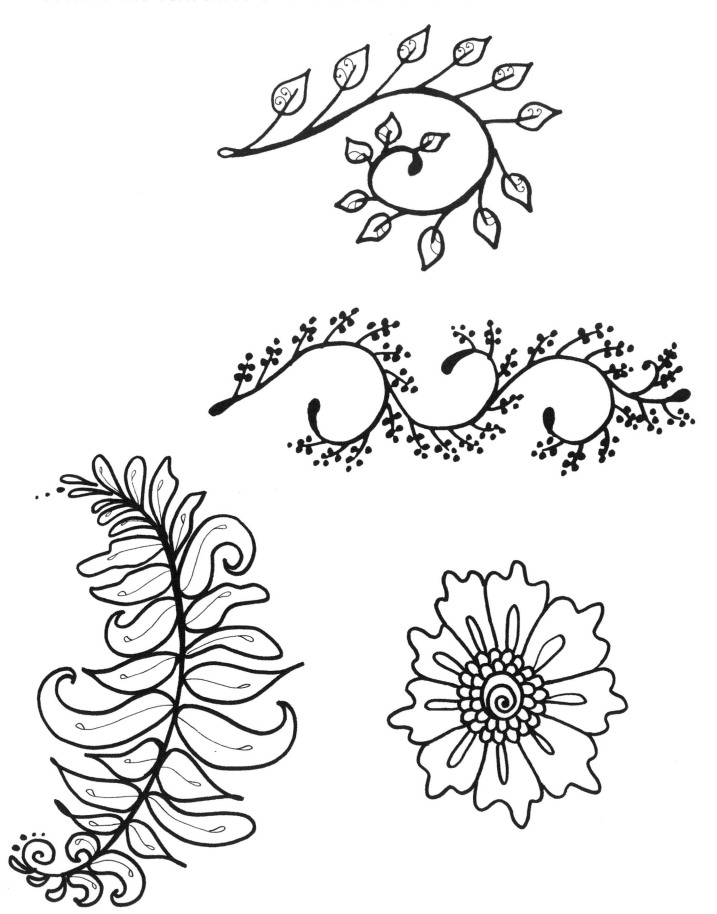

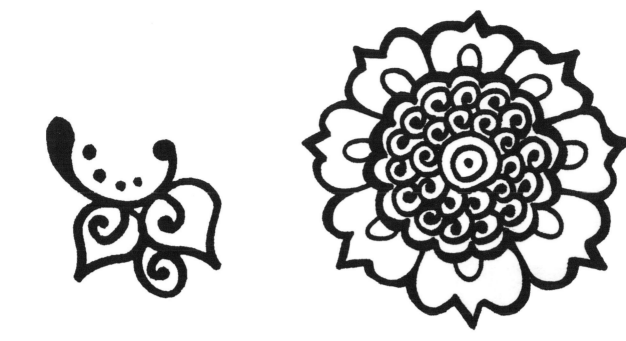

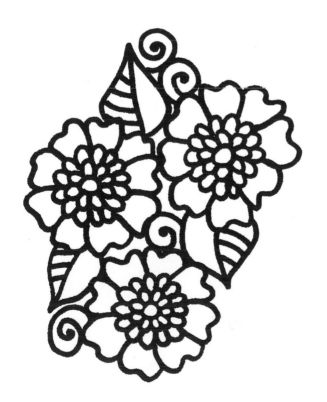

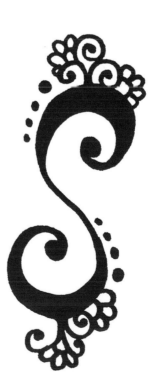

TEMPLATES

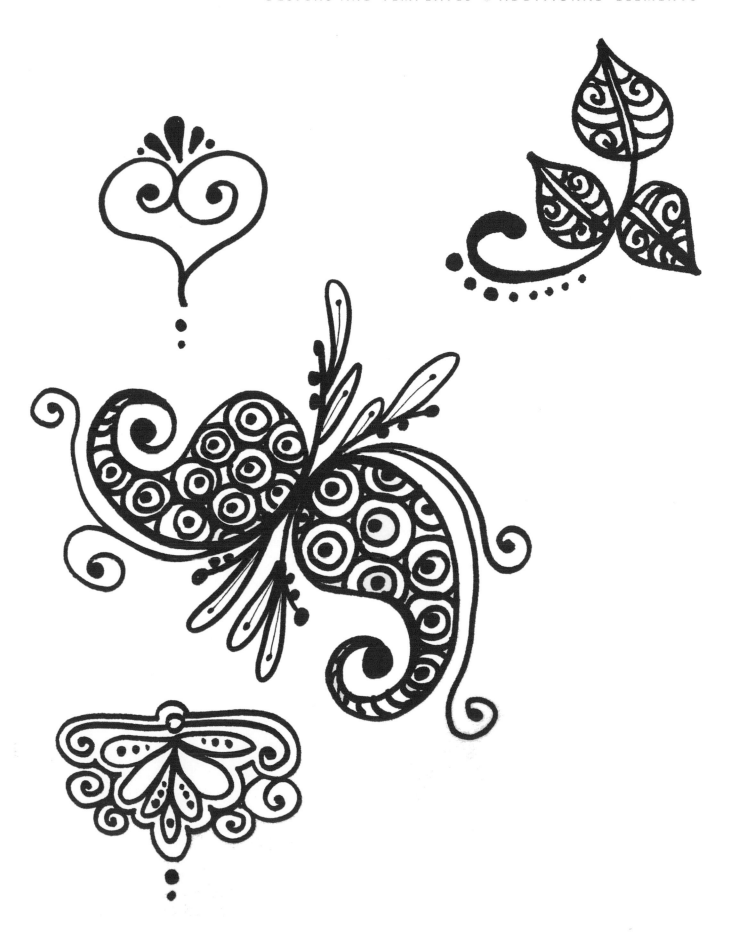

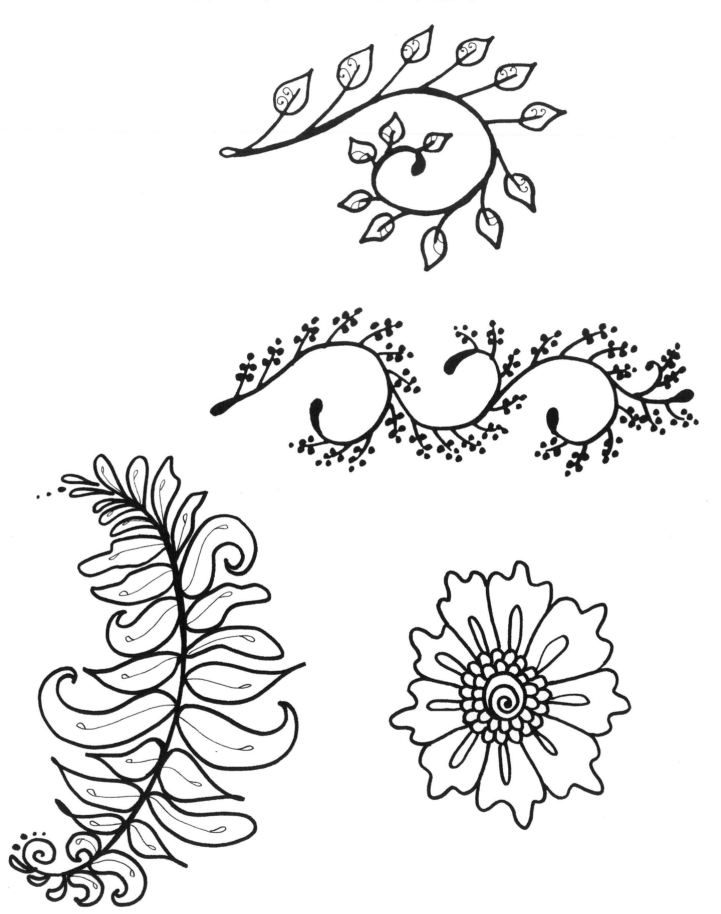

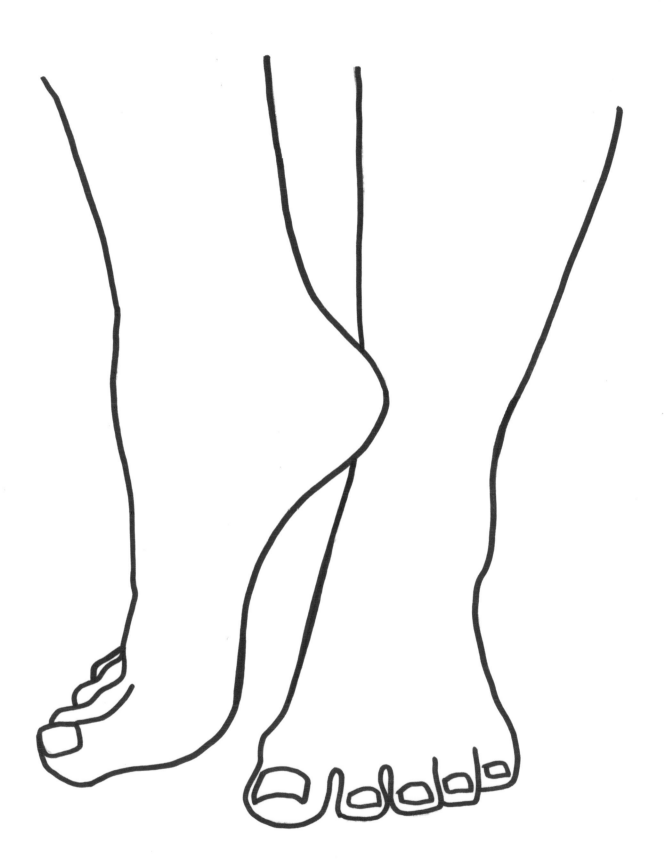

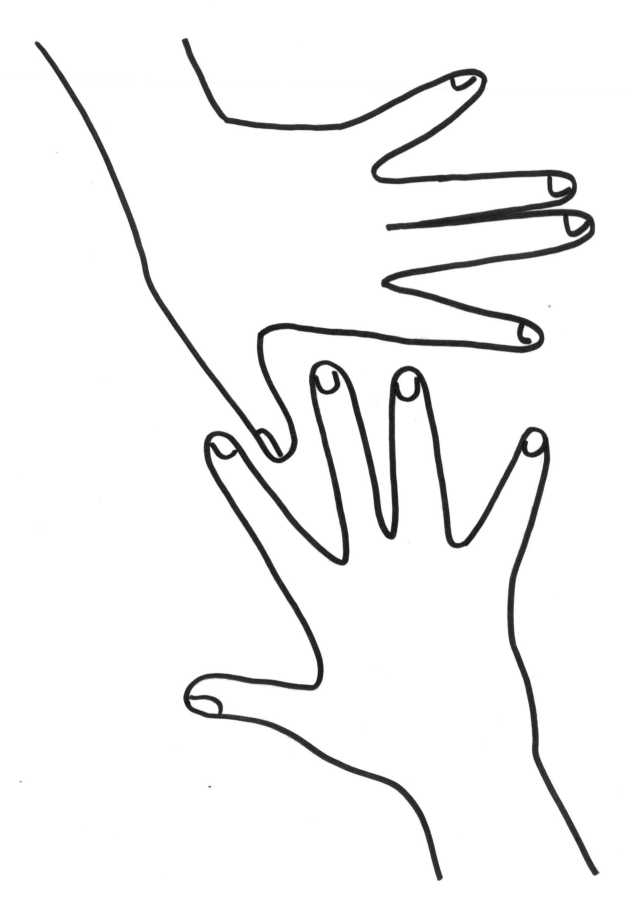

Teach Yourself Henna Tattoo

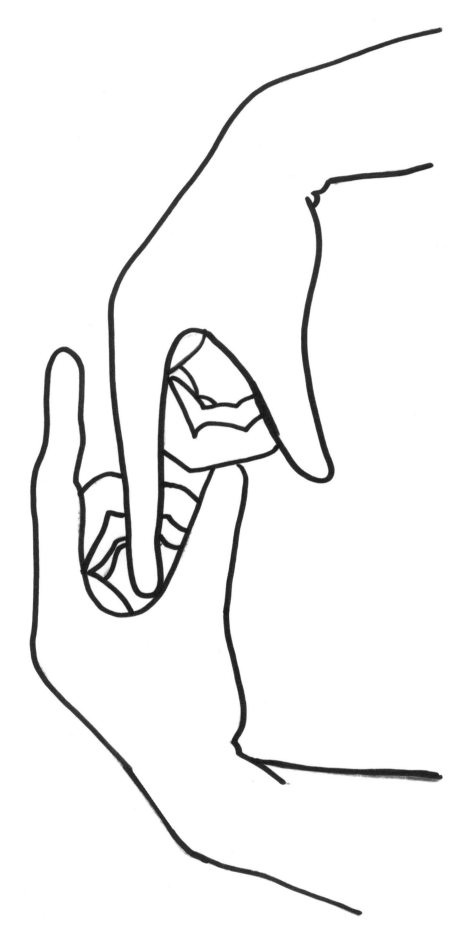

Henna as Artwork

Henna paste will stain not just skin, but also other porous, organic items. Unfinished wooden boxes and jewelry are ideal surfaces to decorate with henna tattoos. Animal skins, such as leather and the heads of drums and tambourines, also take henna stain very well. Simply apply the tattoo, let it dry, and brush it off. The design that's left behind is beautiful on its own, but you can also embellish it even more with paints, beads, and sparkling jewels.

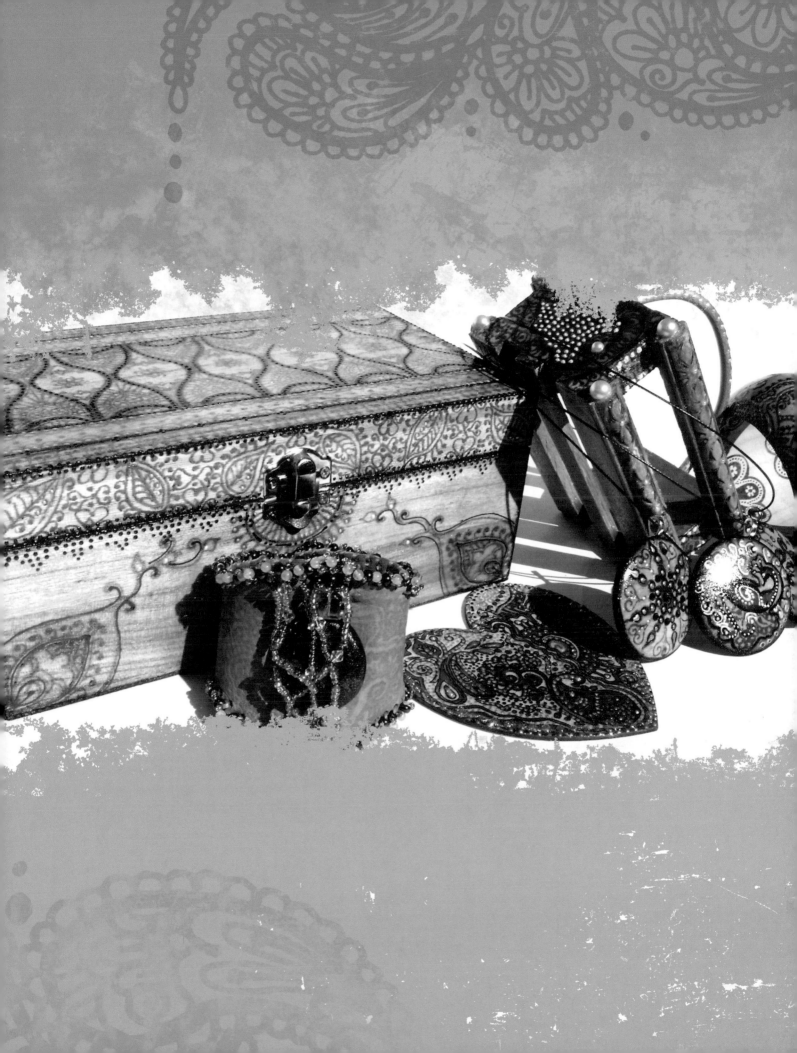

DOING HENNA ON OBJECTS

3

Remove the dried henna paste with a blunt, hard object.

1 **Apply the henna.** Most people would describe freehand henna art as an advanced henna art skill. I do not subscribe to that belief. The same four or five basic strokes (see pages 23–25) once again come into play for henna designs on objects such as wood. However, there is one important difference: it is difficult to remove a mistake caused by misplaced henna paste on wood. Remember to allow yourself a few imperfections as you work. The handcraft of a henna artist is unique and special based on the fact that no two henna creations are alike. I suggest going with the flow and momentum of the moment. If an errant bit of henna lands somewhere unplanned, work it into your design. Other options are to touch up the area later with brown- and sepia-toned watercolor pencils or add a black border or outline with permanent marker. Whatever you do, this bit of henna work will become your original art. It will be unique, so go with it!

2 **Let the henna dry.** Once you have applied the entire design, set the object aside in a dry, out-of-the-way place so you will not accidentally bump it and smear the henna paste before it has had a chance to dry. Leave the henna paste on the wood longer than you would leave it on your skin; wood is dry, and the henna will need a little extra time to permeate the surface. I usually allow the henna paste to rest on wood for three to five days. The longer you leave it on, the deeper the color will be. Like with your skin, the surface will continue to absorb the stain and it will deepen in hue over time.

3 **Remove the paste.** When you are ready to remove the dry paste, use a blunt, hard edge of an old credit card or some other firm object to scrape the dry paste from the surface. Be careful not to press so hard that you mar or scratch the surface.

4 **Outline with marker.** If desired, you can outline the henna with a fine point, permanent black marker after removing the paste. To outline, simply follow the natural edges of your henna design. You can make the outline as thin or as thick as you like in order

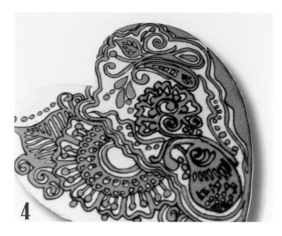

4

Outlining the lines of henna give the project a whole different look.

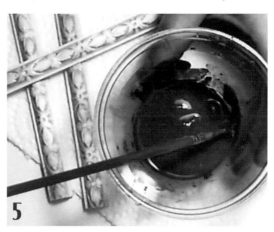

5

Mix 2 Tbsp. water and 2 Tbsp. henna paste to form a wash.

to emphasize the intricate pattern of the henna stain on the wood surface. Because you are outlining all the edges, you will actually cover twice the amount of surface area of the henna design. This process can be time-consuming. Be patient. A slip of the wrist with permanent marker can leave a mark that might be difficult to work into your design.

5 **Apply a henna wash.** Sometimes you will want to accent parts of your design with a wash of darker color—this works best on wood. To make a henna wash, place 2 Tbsp. (30 ml) of henna paste into the small bowl with 2 Tbsp. (30 ml) of water. Stir the paste and water to create a thin henna wash that you can brush on. Apply the wash with an old paintbrush, using the same process that you would use to apply any other standard stain or paint. Allow the pieces to dry completely then rest for another 48 to 72 hours. After this waiting period, remove the henna wash, which is now a dried henna film. Use a firm-bristled toothbrush to get into the crevasses and remove all the excess henna paste.

6 **Extra touches.** For an extra glimmer, I like to apply two-dimensional paints. I use Paper Effect paints by DecoArt, which can be found in the scrapbooking section of your local craft store. Before the dimensional paint dots dry, dust the entire surface with

microfine translucent holographic glitter for maximum sparkle. Glamour Dust by DecoArt is ideal. Once the dimensional paint has dried completely, about 5 to 10 minutes, seal the entire surface with a high-gloss sealant.

7 **Apply sealant.** My personal favorite sealant is Triple Thick by DecoArt. Apply three moderate coats, allowing each coat to dry completely before proceeding to the next. For a higher shine, lightly buff each dry coat with ultrafine steel wool before applying the next coat.

Notes on working on large surfaces. Stamina, a steady hand, and specific use of all of your freehand henna art skills will be required to complete large projects. The challenge is to keep your henna strokes even and to push through the design so that all the henna is stained at as close to the same color depth as possible. If too much time elapses between one side of the project and the other, the depth of the henna stain will vary also, changing the tone from edge to edge. When I decorate a large surface, like a box, I do not hold myself to a particular plan; rather, I do random, continuous henna work until I am satisfied that the artwork is complete.

TIP When working with wood, make sure the wood is unfinished. Varnish, paint, or any kind of natural finish like linseed oil will prevent the henna from staining the wood.

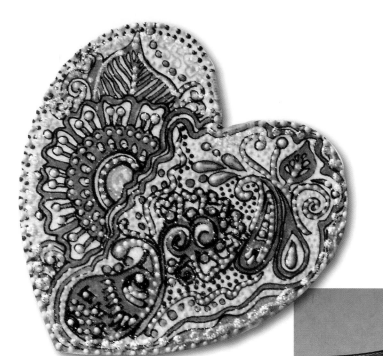

This heart-shaped piece of wood was a great canvas for freehand henna. I attached a magnet to the back to add some henna to my refrigerator.

TIP When working with henna on objects, keep at least two full and ready-to-use henna cones available so you can complete the entire henna application in one go. Why? Because the faster you can apply the paste with precision, the more even the color of your design will be.

I used a peacock design on this wooden pendant. The addition of some paint and glitter really makes it pop. The challenge here was to keep the henna strokes smaller than usual.

TIP Henna paste needs to sit on the surface of wooden objects longer than on your skin to be fully absorbed. Plan for three to five days. The color will continue to deepen a bit after you remove the paste.

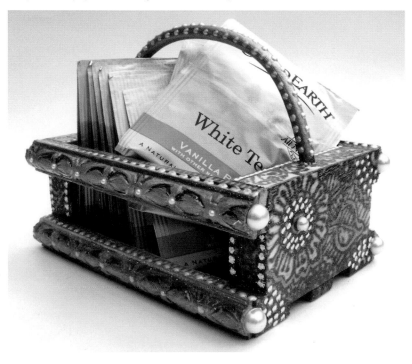

This tea caddy project was lots of fun; I used rhinestones and some paint dots to really accent the design.

TIPS FOR WORKING ON A BANGLE

Anchor and position the bangle blank on your non-dominant hand by threading your hand through the center of the bangle up to your knuckles. Push the bangle onto your knuckles just enough to hold it tight, but not enough to push it over onto your wrist. You could also use a Styrofoam floral cone from your local craft store. Be sure it is at least 4" in diameter at the bottom so your bangle will not fall off. A construction paper roll or the neck of a two-liter bottle are also options.

Start your design at the peak of the dome and work your way out to the rim. Try to work in a 2" x 2" (5 cm x 5 cm) space, then turn the bangle to the next 2" x 2" (5 cm x 5 cm) space and continue on around the bangle.

It is important to note that the first time you take on a project of the size and complexity of a bangle, your hands might get tired midway through. If you're working with the bangle on your knuckles, set the bangle over the bottom of an over-turned paper cup while you rest or stretch your hand so you can continue.

You may want to continue the design over the edge of the bangle and onto the inside surface. Wait at least two days until the outside is dry before you continue on the interior. If you have continued artwork to the inside, seal that with a matte sealant; gloss finishes will be less comfortable against the skin in warmer weather.

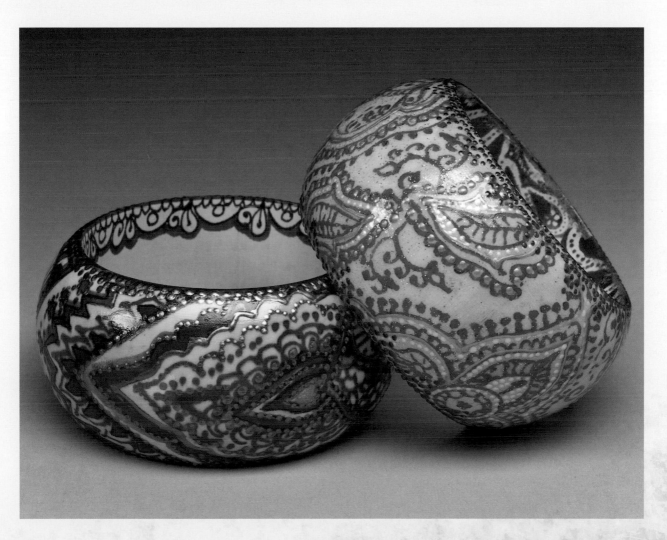

Wooden bangles are an ideal place to experiment with henna designs.
Don't forget that you can decorate the inside of the bangle as well.

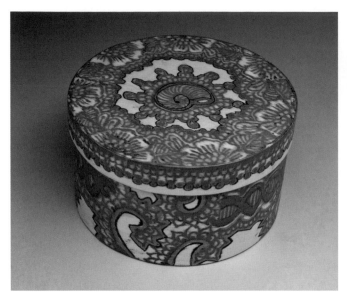

The henna design for this round wooden box was built around the shell at the center of the lid.

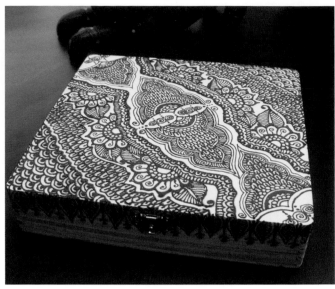

The large square surface of this wooden cigar box gives an artist an ideal space for a large repetitive and almost symmetrical design.

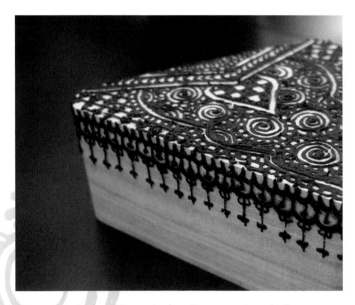

Henna paste dries on this wooden box. You can see how the henna decoration extends over the sides of the lid.

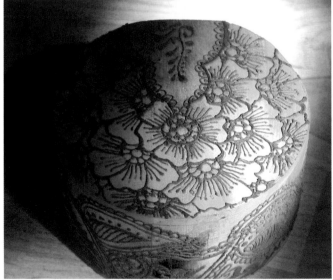

Color a surface before applying the henna paste to add another dimension to your artwork. This blue box was stained with colored permanent bottle inks; true paints will prevent the henna from leaving a stain.

Henna wash was used to create subtle shading between the darker lines of these henna designs on wooden boxes.

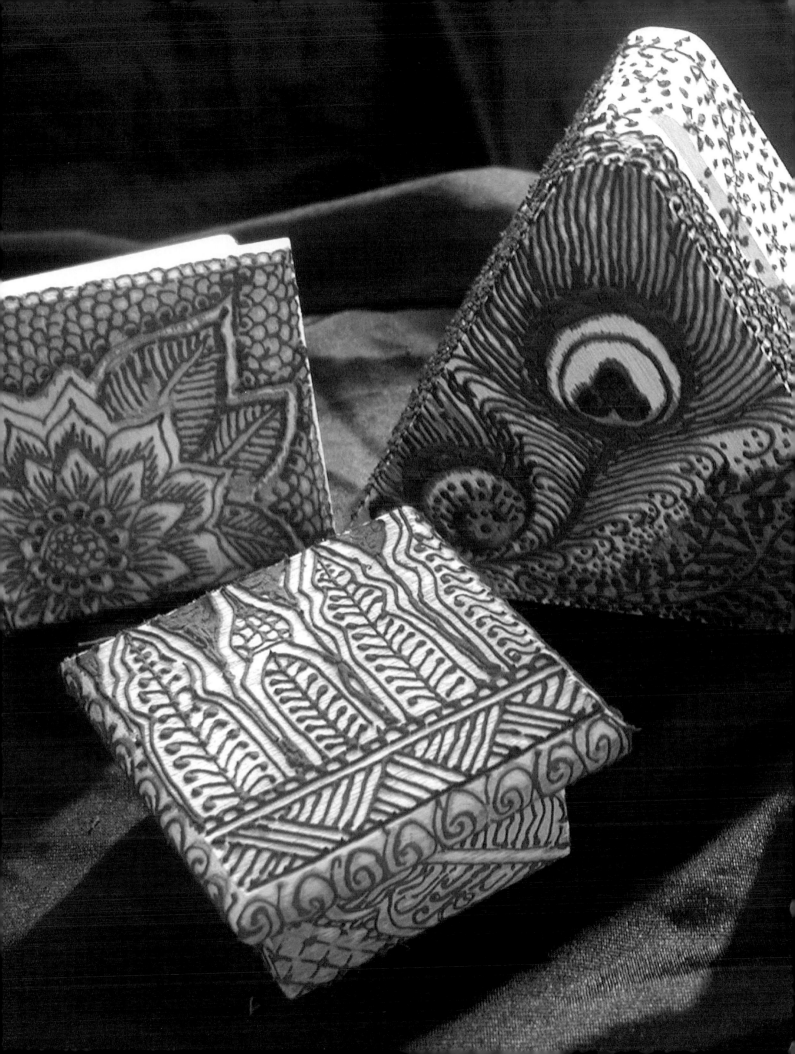

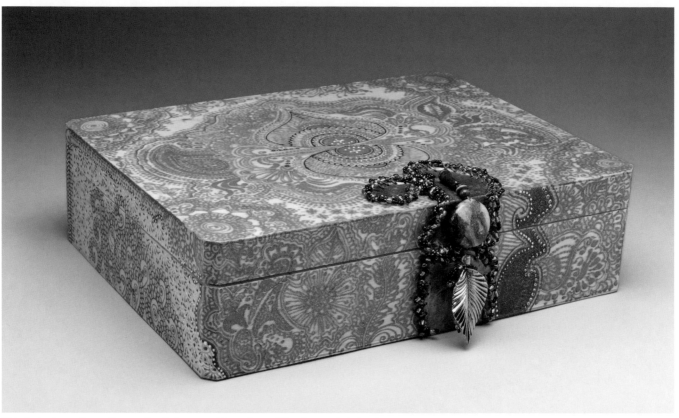

This design is a collage of henna florals, leaves, swirls, curlicues, filler dots, and circles that simply run together to create an intricate pattern of henna artwork.

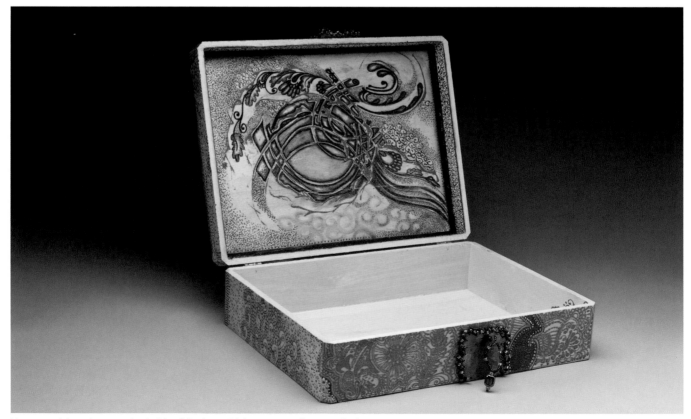

You may wish to decorate the inside of the box with henna as well, or simply draw or decoupage inside.

ADDING A BEADED LEATHER LATCH

1. Decide on shape. I like making freeform latches, but you can do whatever fits your liking and project best. Cut out the leather in the shape you want for the upper (lid) and lower (box) pieces.

2. Punch for beads. If you want to have your latch edged with beads, you will need to punch holes approximately ⅛" (3mm) apart along the outer edge of your leather scraps. Do not punch the bottom edge of the lower latch.

3. Thread on the first layer of beads. Thread a length of faux sinew (long enough to whip stitch around the entire piece) through one of the holes from the bottom, slide a bead onto the sinew, then whip stitch around the outer edge of the leather and bring the thread up from the bottom through the next hole. Continue in the same manner until you run out of holes or return to the beginning. Secure the ends by knotting them and trim the tails.

4. Wire on the second layer of beads. Cut a long portion of copper 24-gauge beading wire (at least as long as the faux sinew). Thread the wire up from the back side of the first hole and through the bead already there, slide a new bead or beads on the wire, then thread the wire through the next already-laced bead. Continue until you return to your starting point. Thread the wire through the starting bead, twist the two tails together, then bend them under the bottom and toward the center of the latch piece.

5. Add third layer of beads. If desired, add a third layer of beads by repeating Step 4.

6. Thread the focal bead. Punch a small hole, just large enough for a double thickness of the faux sinew. Thread one end through the hole you punched in the center of the leather latch then thread it through your focal bead. The bead should dangle directly in front of the lower portion of the leather latch. You could add additional smaller beads to cover the excess sinew above the focal bead. You can also add charms below the focal bead (see photos on opposite page).

7. Secure the focal bead. Bring the thread back through the beads and the leather. Tie a double square knot large enough to stop the sinew from being pulled back through the hole.

8. Create the bottom latch. Punch a very small hole in the center of the lower latch. Thread a piece of copper wire through the hole and create a loop. If you want to bead the loop, do that now. Twist the tails and fold the ends to the underside.

9. Adhere the latch to the box. Place a generous portion of leather cement on the back of the latch pieces, position them where desired, and secure the leather and the box with a spring clamp or C clamp. Allow the glue to dry completely according to the manufacturer's recommendations. Before you clamp the lower latch in place, check the focal bead and loop to make sure the loop will reach over the bead. See an example of a finished beaded leather latch on page 106.

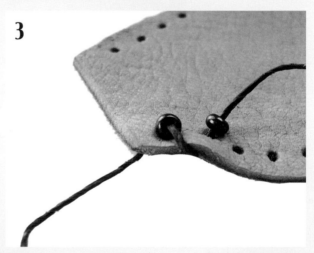

The first layer of beads. String beads on sinew, creating a whipstitch along the edge of the latch pieces.

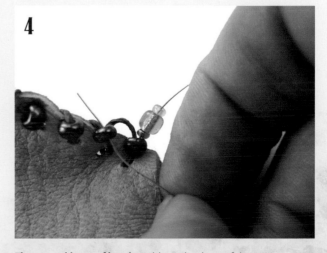

The second layer of beads. Add another layer of decorative beads by stringing them on a smaller gauge wire.

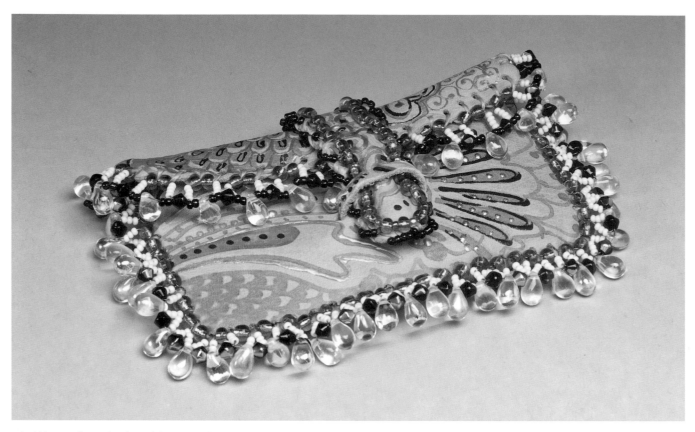

A bold henna design, beads, and dimensional paint are
used to decorate this leather wallet.

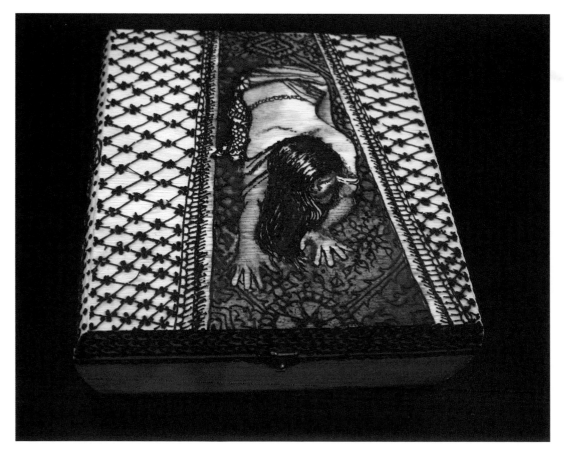

Henna art does not need
to be limited to floral or
geometric designs.

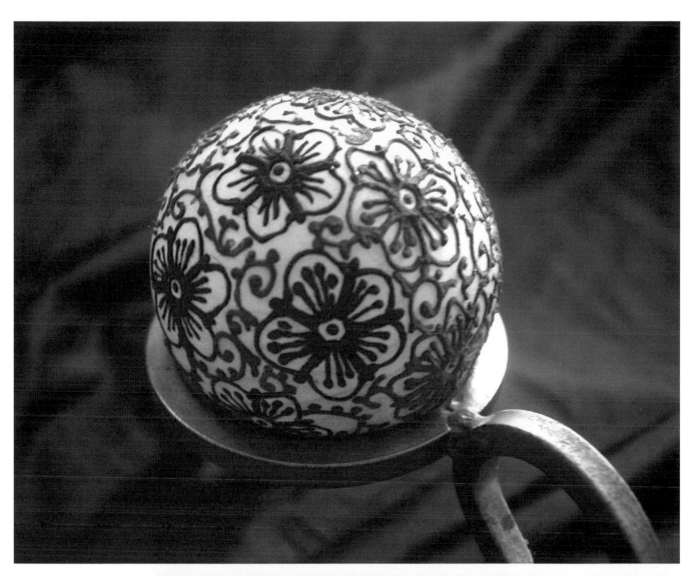

A spherical surface like this round wooden ball gives the artist an ideal canvas for a continuous repetitive design.

Henna paste will also stain leather used for jewelry and clothing. A loop of smaller beads and a larger bead fastened directly to the leather create a clasp.

RESOURCES

SUPPLIES

HENNA POWDER

www.beachcombersbazaar.com
www.thehennapage.com

JAC BOTTLES

www.beachcombersbazaar.com
www.thehennapage.com
www.JacquardProducts.com

ESSENTIAL OILS (TEA TREE AND OTHERS)

www.beachcombersbazaar.com
www.thehennapage.com

READY-MADE MYLAR CONES

www.thehennapage.com

BAJIDOO HOW-TO VIDEOS

www.youtube.com/user/babdoyan

BRENDA ABDOYAN, BAJIDOO, INC.

www.bajidoo.com
www.brendaabdoyan.net

HAVE MORE QUESTIONS?

info@bajidoo.com or *abdoyan@bajidoo.com*

INDEX

Acquisition Editor: Peg Couch

Cover and Page Designer: Lindsay Hess

Developmental Editor: Ayleen Stellhorn

Editor: Kerri Landis

Layout Designer: Ashley Millhouse

Proofreader: Lisa Caylor

More Great Books from Design Originals

Zentangle Basics, Expanded Workbook Edition
ISBN 978-1-57421-904-3 **$8.99**
DO5462

Joy of Zentangle
ISBN 978-1-57421-427-7 **$24.99**
DO5398

The Beauty of Zentangle®
ISBN 978-1-57421-718-6 **$24.99**
DO5038

Zenspirations™ Coloring Book Inspirations Designs to Feed Your Spirit
ISBN 978-1-57421-872-5 **$9.99**
DO5446

Zenspirations™ Coloring Book Flowers
ISBN 978-1-57421-869-5 **$9.99**
DO5443

Zenspirations™ Coloring Book Abstract & Geometric Designs
ISBN 978-1-57421-871-8 **$9.99**
DO5445

Ideas & Inspirations for Art Journals & Sketchbooks
ISBN 978-1-57421-379-9 **$16.99**
DO3502

Friendship Bracelets
ISBN 978-1-57421-866-4 **$9.99**
DO5440

Hello! Macramé
ISBN 978-1-57421-868-8 **$12.99**
DO5442